D1616593

HISTORIC PHOTOS OF
SACRAMENTO

TEXT AND CAPTIONS BY JAMES SCOTT AND TOM TOLLEY

Turner®
Publishing Company
Nashville, Tennessee • Paducah, Kentucky

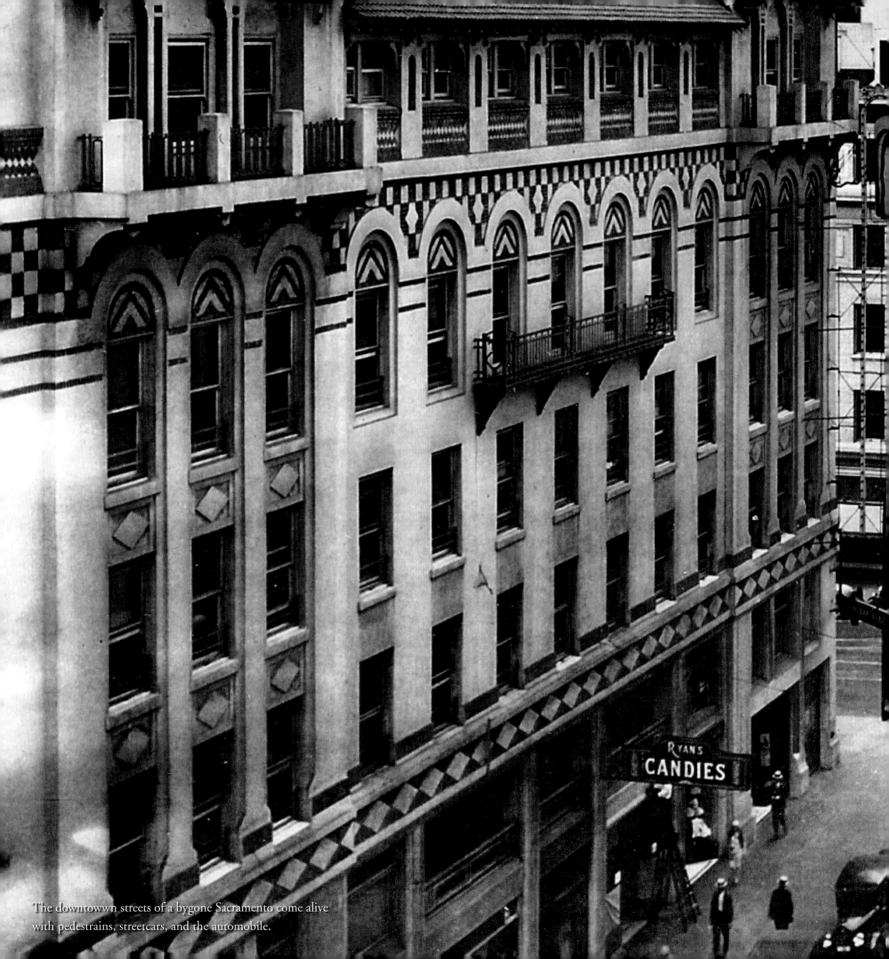

RYAN'S CANDIES

The downtowwn streets of a bygone Sacramento come alive with pedestrains, streetcars, and the automobile.

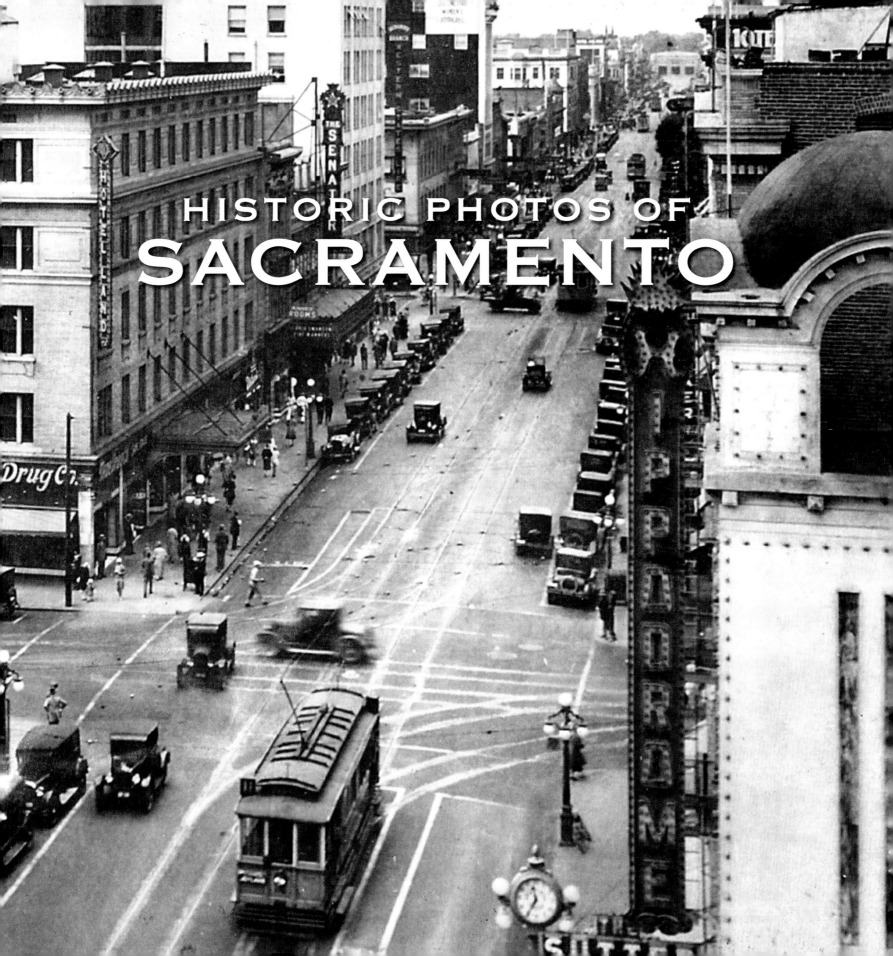

HISTORIC PHOTOS OF
SACRAMENTO

Turner Publishing Company

200 4th Avenue North • Suite 950 412 Broadway • P.O. Box 3101
Nashville, Tennessee 37219 Paducah, Kentucky 42002-3101
(615) 255-2665 (270) 443-0121

www.turnerpublishing.com

Library of Congress Control Number: 2006935405

ISBN: 1-59652-308-5

Printed in the United States of America

07 08 09 10 11 12 13 14 15—0 9 8 7 6 5 4 3 2 1

CONTENTS

An unusual scene of a horse-drawn buggy on the streets of
Sacramento well inot the established automobile era.

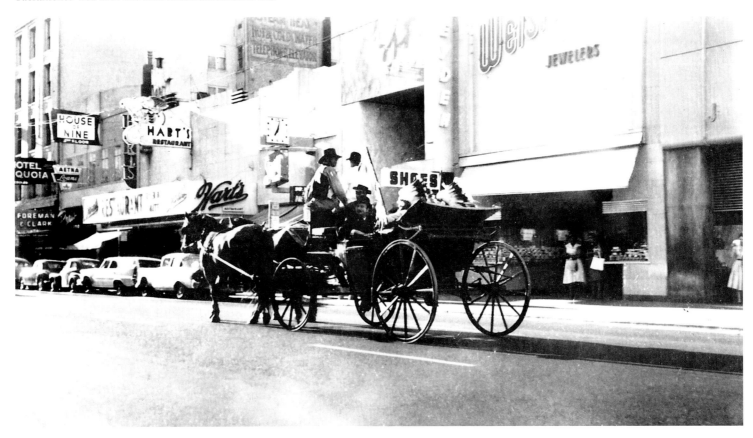

Acknowledgments

This volume, *Historic Photos of Sacramento,* is the result of the cooperation and efforts of one exclusive archive. It is with great thanks that we acknowledge the valuable contribution of the Sacramento Archives and Museum Collection Center.

We would also like to thank James Scott and Tom Tolley for valuable contributions and assistance in making this work possible.

Preface

Sacramento has thousands of historic photographs that reside in archives, both locally and nationally. This book began with the observation that, while those photographs are of great interest to many, they are not easily accessible. During a time when Sacramento is looking ahead and evaluating its future course, many people are asking, How do we treat the past? These decisions affect every aspect of the city—architecture, public spaces, commerce, infrastructure—and these, in turn, affect the way that people live their lives. This book seeks to provide easy access to a valuable, objective look into the history of Sacramento.

The power of photographs is that they are less subjective than words in their treatment of history. Although the photographer can make decisions regarding subject matter and how to capture and present it, photographs do not provide the breadth of interpretation that text does. For this reason, they offer an original, untainted perspective that allows the viewer to interpret and observe.

This project represents countless hours of review and research. The researchers and writer have reviewed thousands of photographs in numerous archives. We greatly appreciate the generous assistance of the individuals and organizations listed in the acknowledgments of this work, without whom this project could not have been completed.

The goal in publishing this work is to provide broader access to this set of extraordinary photographs that seek to inspire, provide perspective, and evoke insight that might assist people who are responsible for determining Sacramento's future. In addition, the book seeks to preserve the past with adequate respect and reverence.

With the exception of touching up imperfections caused by the damage of time and cropping where necessary, no other changes have been made. The focus and clarity of many images is limited to the technology and the ability of the photographer at the time they were taken.

The work is divided into eras. Beginning with some of the earliest known photographs of Sacramento, the first section

records photographs through the end of the nineteenth century. The second section spans the beginning of the twentieth century to the World War I era. Section Three moves into the period between the wars. The last section covers the World War II era up to recent times. In each of these sections we have made an effort to capture various aspects of life through our selection of photographs. People, commerce, transportation, infrastructure, religious institutions, and educational institutions have been included to provide a broad perspective.

We encourage readers to reflect as they go walking in Sacramento, strolling through the city, its parks, and its neighborhoods. It is the publisher's hope that in utilizing this work, longtime residents will learn something new and that new residents will gain a perspective on where Sacramento has been, so that each can contribute to its future.

Todd Bottorff, Publisher

Central Pacific Depot in downtown Sacramento (ca. 1880)

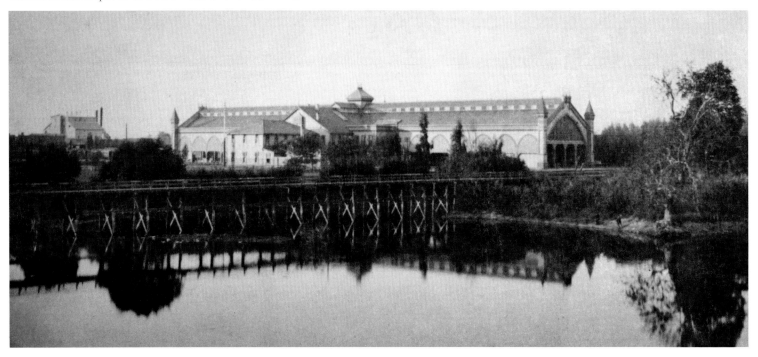

A City in the Right Place, at the Right Time

1800s–1899

Born of early ambitions for empire and spurred to growth by the discovery of gold in 1848 and its ascension to state capital in 1854, Sacramento's rise as a city proved inevitable. Even with the ebb of the Gold Rush, and despite flood, fire, and disease, by 1860 the city had grown into a diverse population of nearly 10,000—proof that California's first incorporated city would be more than a boomtown, boasting complex institutions of government, trade, transportation, agriculture, culture, and worship.

Early signs of civic growth came with the construction of various public and private buildings. Citizens convened in these palpable symbols of progress to address the issues of the day. Sacramento even sought to emulate the architectural sophistication and grandeur of more established communities by building a Greco-Roman-style courthouse and a state capitol which, completed in 1874, resembled the U.S. Capitol.

Sacramento's love affair with, and dependence on, rail transportation started in 1855 when the 22-mile-long Sacramento Valley Railroad offered passenger service—the first railroad to do so in the American West—from Sacramento to Folsom. In 1863, the Central Pacific Railroad came through. Starting in Sacramento, it formed the Transcontinental Railroad's western leg. By 1895, streetcars powered by hydroelectricity reached points throughout Sacramento and its suburbs.

This revolution on rails invigorated Sacramento's economy, introducing new markets and a fast, reliable way to send and receive goods. Rail yards also meant that the need for unskilled labor was near constant, ensuring merchants, like the Weinstock-Lubin Mechanics' Store, a steady consumer base. A port on the Sacramento, the state's longest river, offered access to a bevy of local markets, and beyond that, the open sea.

Sacramento also became home to some of the finest artisans in the nation. Saddlers, furniture makers, and brewers found a city teeming with demand, as well as lively business districts on "J" and "K" streets to showcase their wares. The legendary banking and delivery service of Wells-Fargo had also been gracing Sacramento since 1852.

For entertainment, the city's 30,000 citizens could choose from up to 200 rollicking saloons by 1890. Sacramento also loved horse racing, a heritage traceable to 1851 with the Brighton Jockey Club.

By century's end, Sacramento had established itself as one of the most promising cities on the West Coast.

Central Pacific Railroad Depot (ca. 1882)

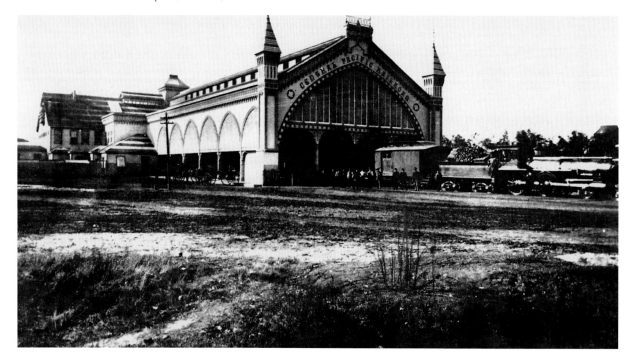

Post Office near St. Rose Square (ca. 1890)

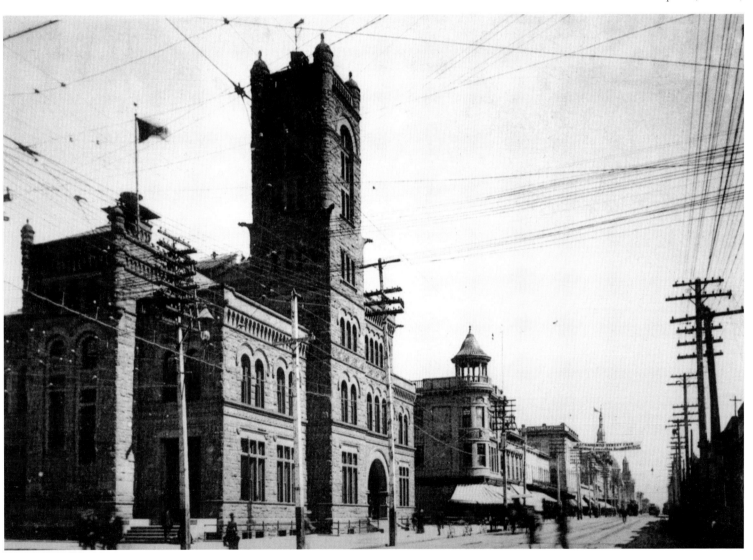

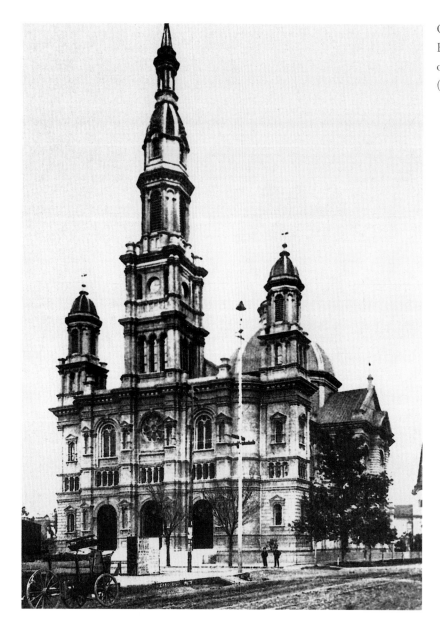

Cathedral of the
Blessed Sacrament
on 11th Street
(ca. 1895)

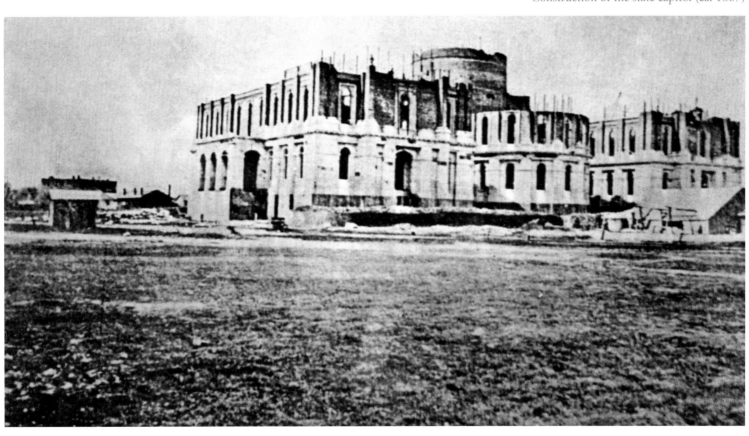

Construction of the state capitol (ca. 1867)

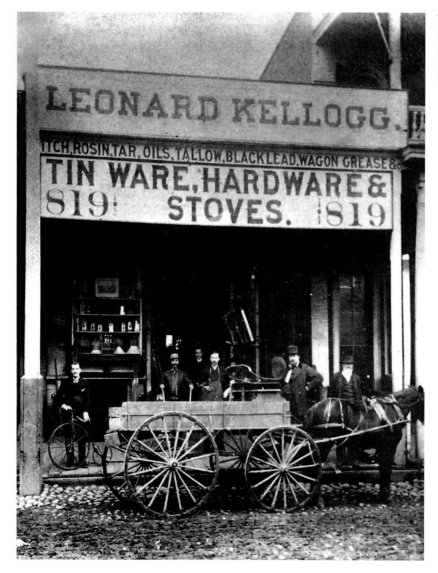

The Leonard
Kellogg
Hardware Store
(ca. 1883)

Wells Fargo Express Building on 2nd Street

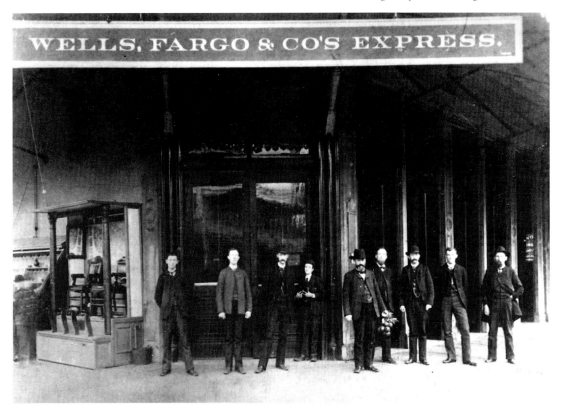

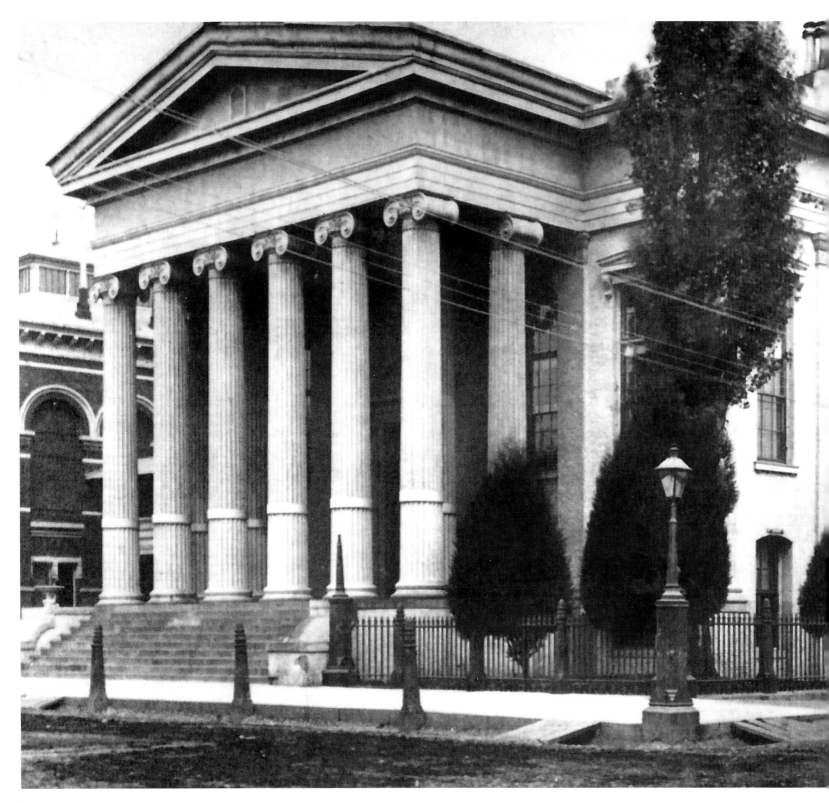

8

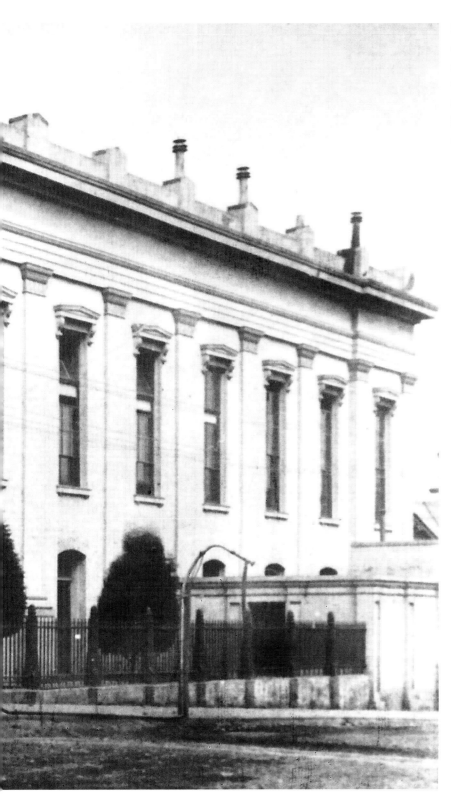

Sacramento County Courthouse on 7th Street (ca. 1865). This second Sacramento courthouse was built in 1855, and it served as a meeting place for the state legislature until the state capitol was completed in 1869.

Sacramento Wharf (ca. 1870)

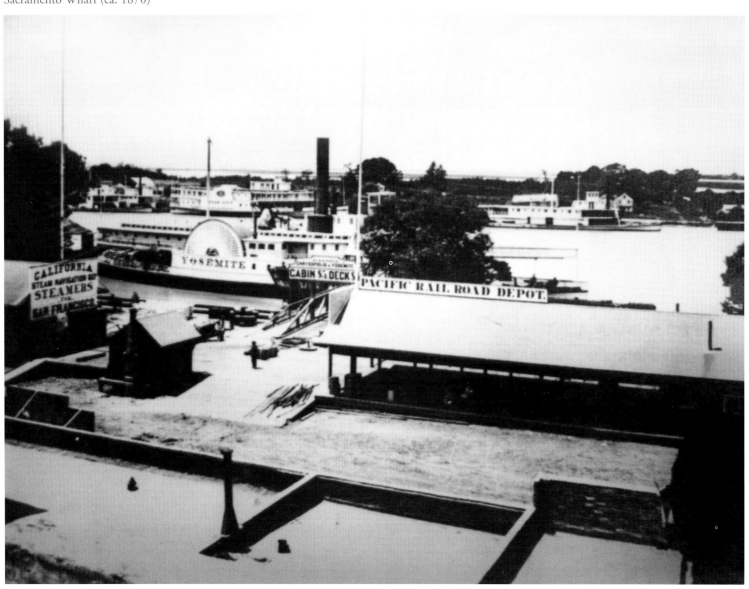

View of Front Street (ca. 1865)

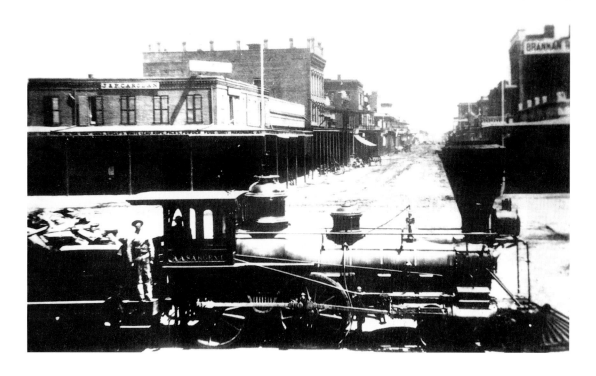

View of 8th Street (ca. 1895)

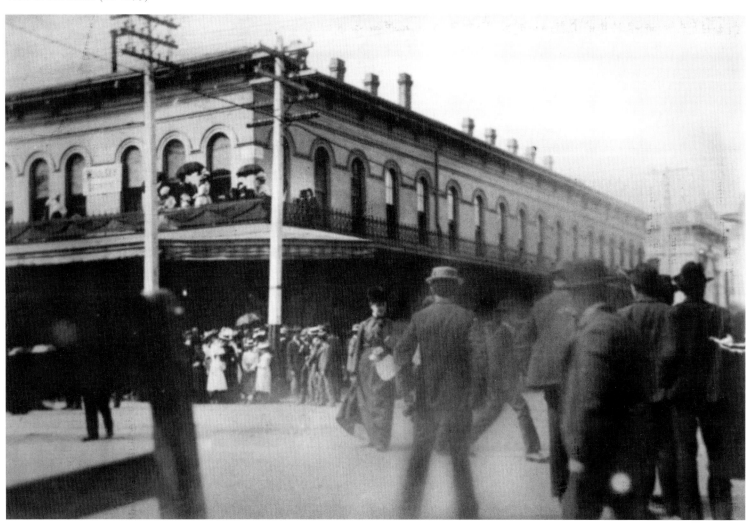

City Brewery on 12th Street (1881). Established ca. 1865

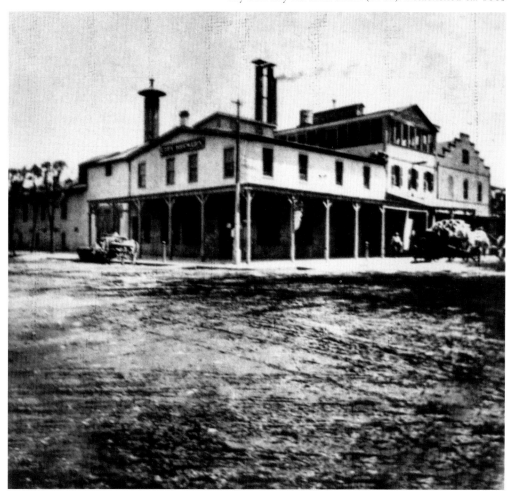

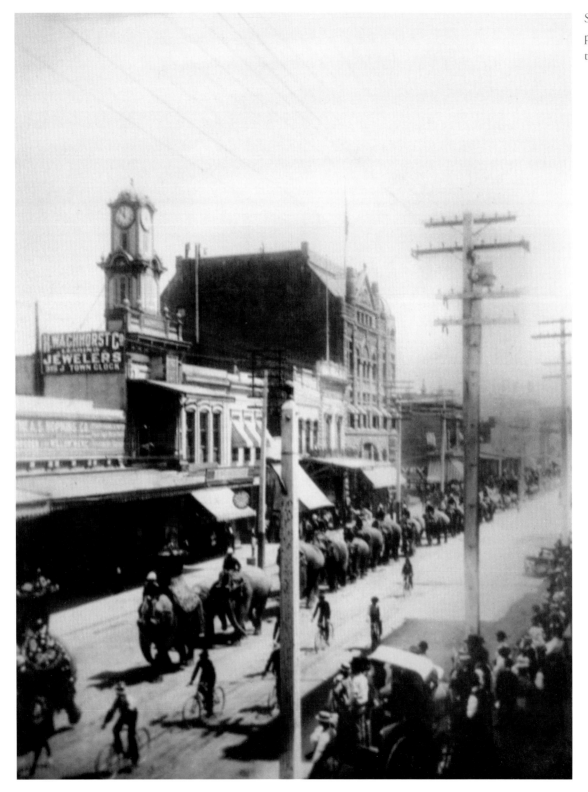

Street fair elephant
parade at the turn of
the century

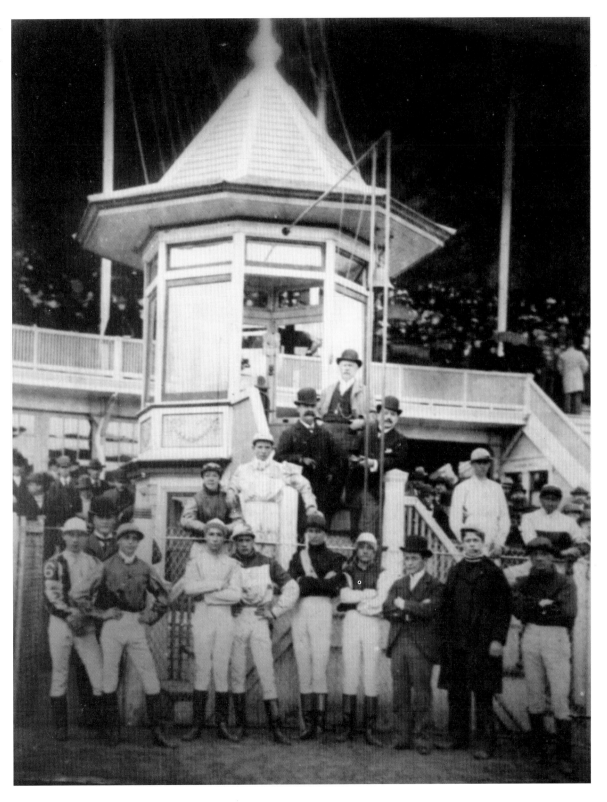

Agricultural Park
racetrack at the
turn of the century

Electric streetcar in downtown Sacramento (ca. 1891)

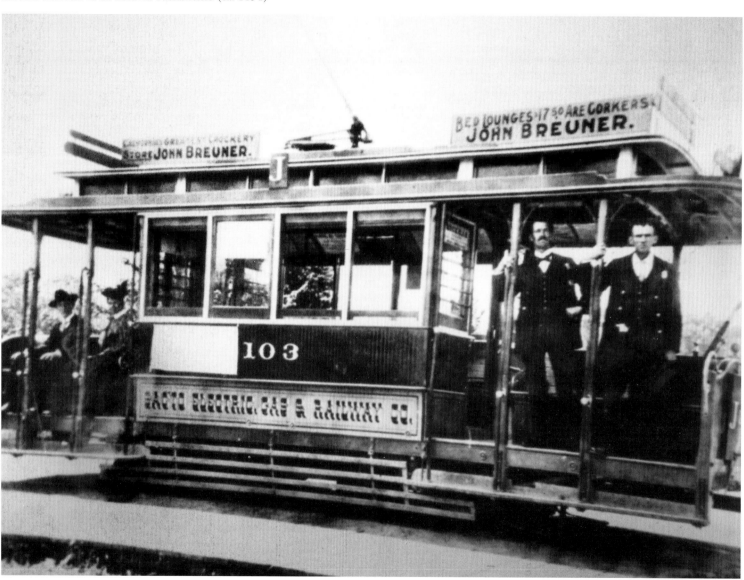

Patrol wagon of the police department. Dubbed the "Black Maria," it served for prisoner transport and as an ambulance. (ca. 1895)

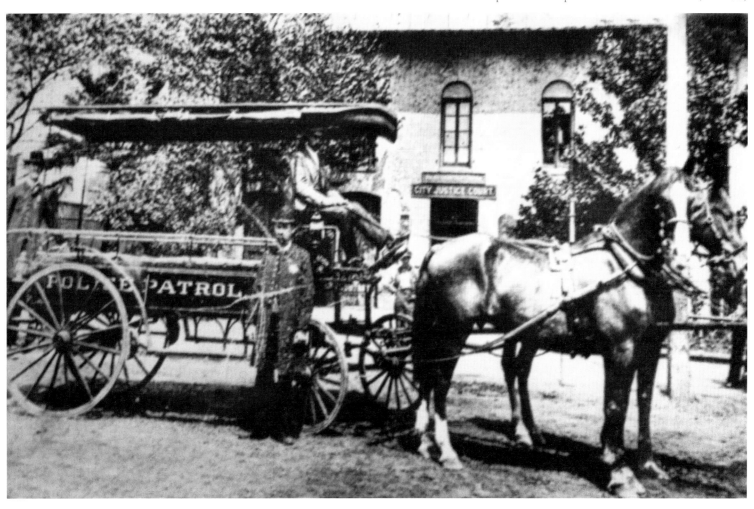

Horse auction at 3rd and J streets (ca. 1879)

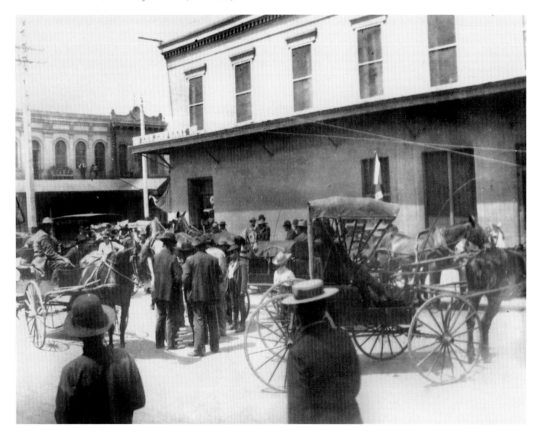

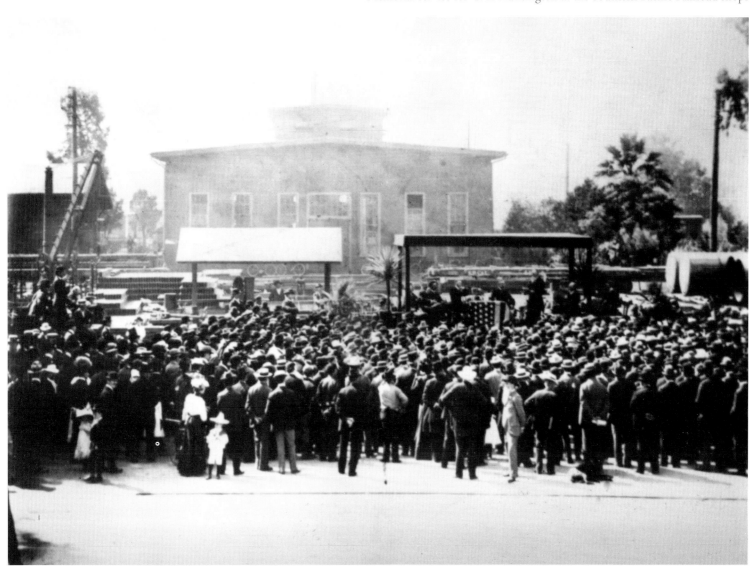

Memorial service for C. P. Huntington at the Southern Pacific Railroad shops

Streetcars in Oak Park at the turn of the century

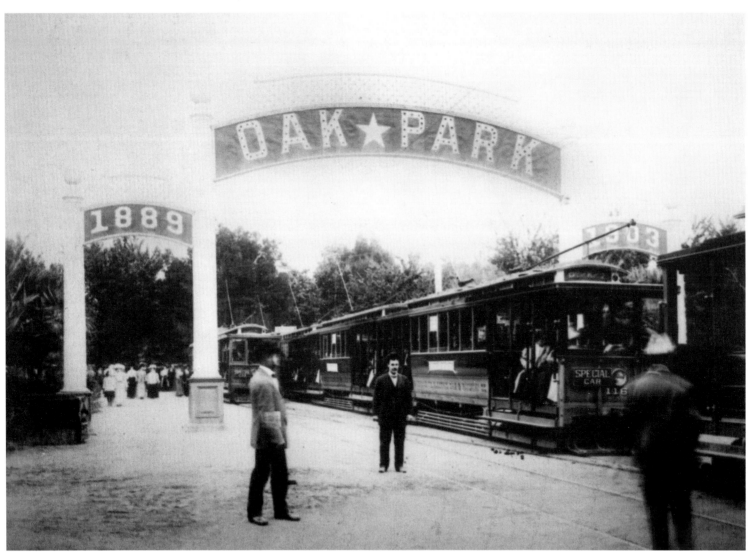

Breuner's Furniture Building (late 1800s)

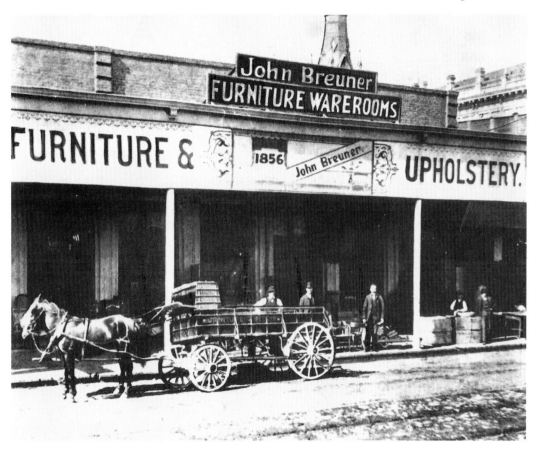

Wells Fargo Express Office, Union Hotel, and Post Office (ca. 1863)

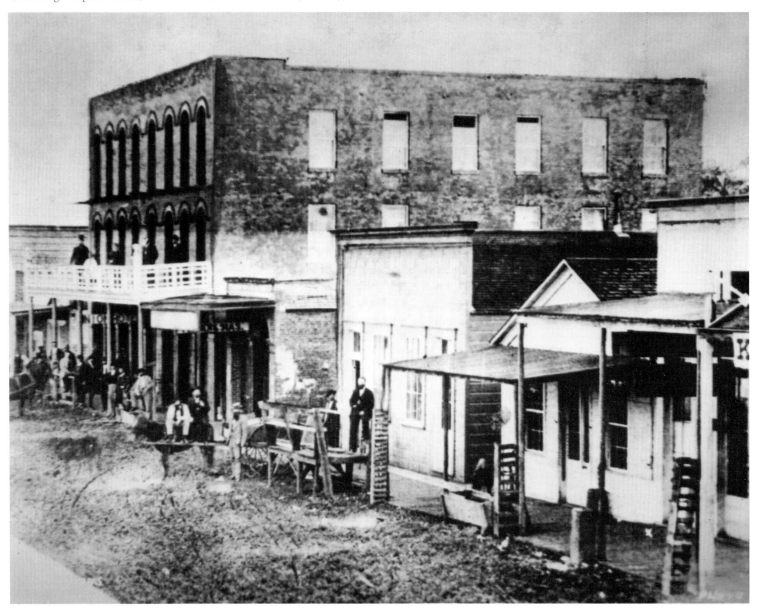

A. A. Van Noorhies and Co., wholesale and retail harness and saddle makers, at its building on J Street at the turn of the century

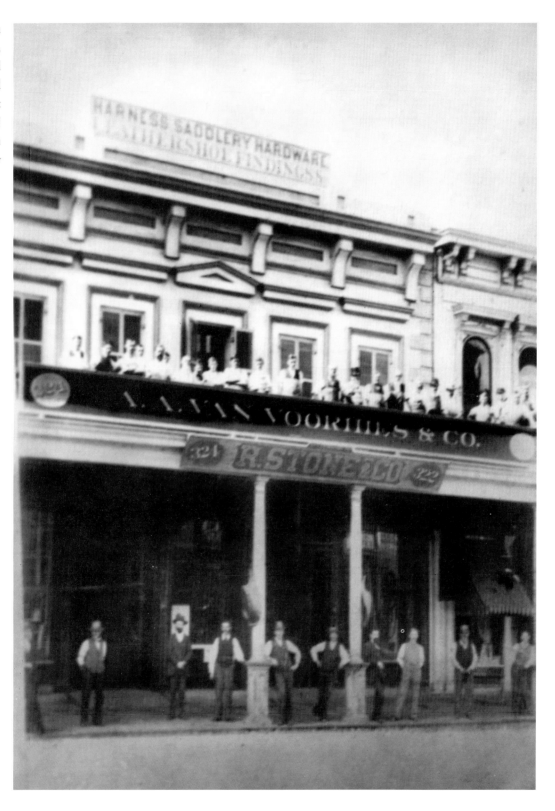

View of J Street (ca. 1868)

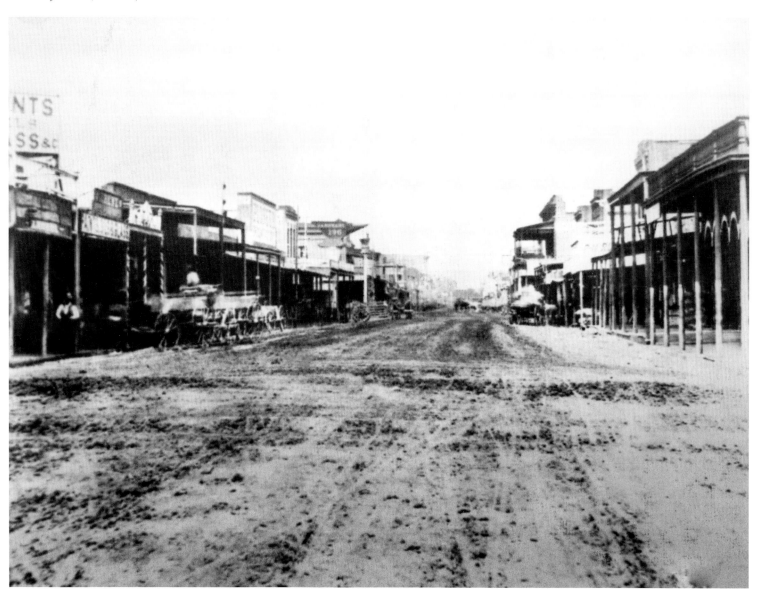

Sacramento's first jail, in service from 1850 until 1861, the Sacramento River, and H Street (ca. 1860)

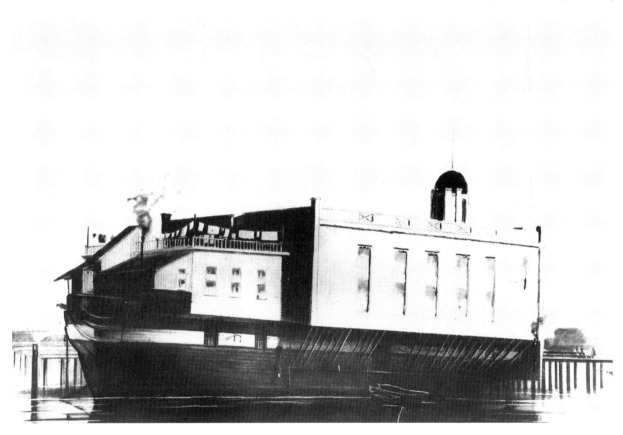

Mechanics' Store on K Street (ca. 1878)

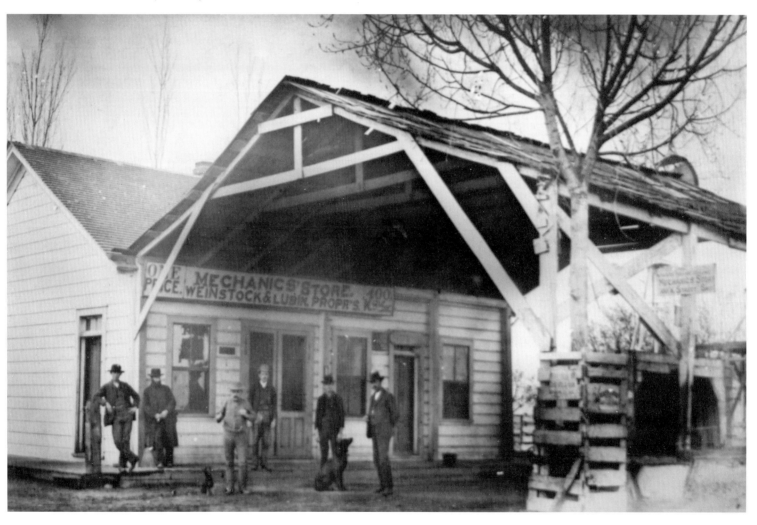

Old Wayside Bar (ca. 1890)

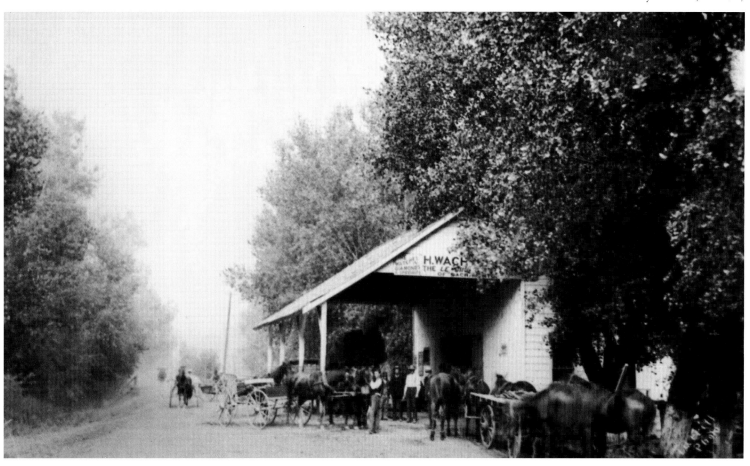

Chinese parade along the Southern
Pacific Railroad tracks

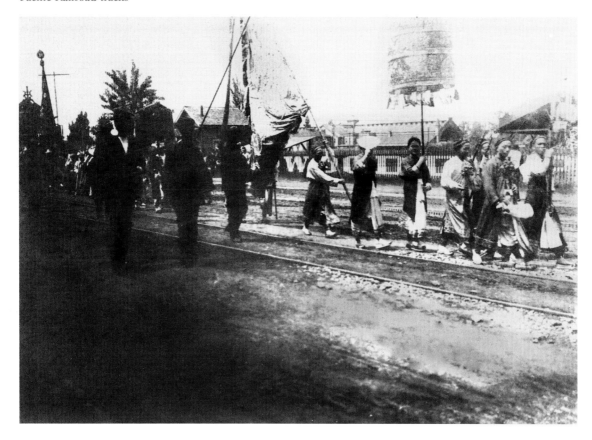

A City Gaining Its Stride

1900–1917

The new century saw Sacramento stretch its economic legs farther. By 1916, the Sacramento Valley was leading the country in the production of peaches, nectarines, pears, plums, and apricots. It was also from Sacramento that rail distribution to the nation would begin, courtesy of the Pacific Fruit Express's 6,000 refrigerator cars. Local brewers also transformed the region's rich hops and barley stands into world-class beers, with producers like Ruhstaller and Buffalo being the latest in a rich pedigree of Sacramento brewers going back to 1848.

Innovations in personal transportation were seen through cycling and automobiling. Sacramento's Capitol City Wheelmen promoted cycling not merely as a means of transportation, but as a healthy way to compete, as exhibited through annual races with Stockton's Oak Leaf Wheelmen. As cycling succumbed to the automobile, the Wheelmen, in 1912, merged with the Capitol City Motorcycle Club, aptly the same year that Sacramento held its first auto show. What arrived as a curiosity brought about a completely new way of life. By 1910, Sacramento County held some 700 automobiles, and horse-drawn vehicles were giving way to the ultra-efficiency of engine-powered tractors as well as the speed and carrying capacity of motor trucks, which shuttled goods up and down Highway 50.

The automobile's advent did little to slow the electric streetcar. Started by the Sacramento Gas and Electric Railway Company in 1892, and carried forth by the Pacific Gas and Electric Company and its competitors, streetcars were not simply shuttling passengers throughout the city—by 1915, interurban streetcars ran between Sacramento and Marysville, Reno, and Auburn.

Sacramento knew well the danger of fire. After the 1903 Weinstock-Lubin Department Store fire, the city began to build a fire department that by 1917 was mechanized, possessing chemical engines, state-of-the-art rubber hoses, retractable ladders, and the fireboat *Apache,* whose four hoses protected the city's valuable port.

Amid the glow of brightening prospects, Sacramento's 45,000 citizens flocked to the California state fair early in the century. The 1912 fair treated onlookers to human flight at an air circus. Five years later, Sacramento's Liberty Iron Works was building JN-4 "Jenny" fighters for the U.S. Army's coming effort in the Great War, a conflict that would both challenge and benefit the Capital City.

Sacramento
County
Courthouse (4th
of July, 1907)

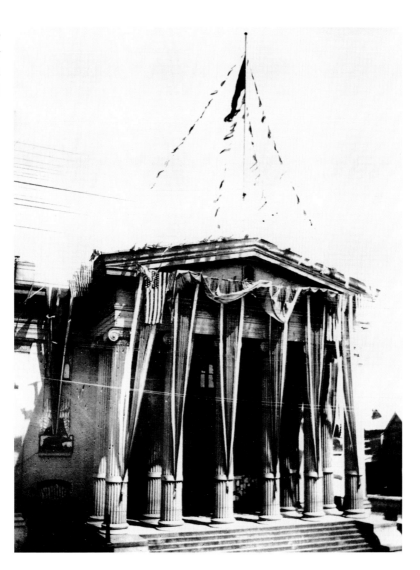

J Street shops (ca. 1910)

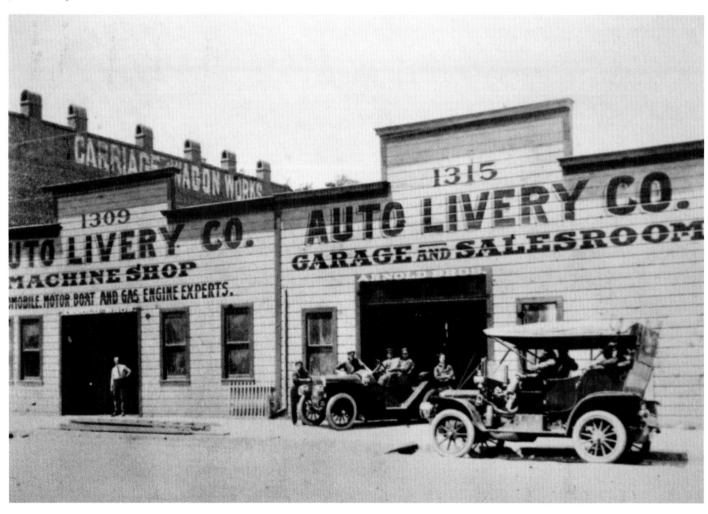

Northern Electric Depot at 8th and J streets (ca. 1909)

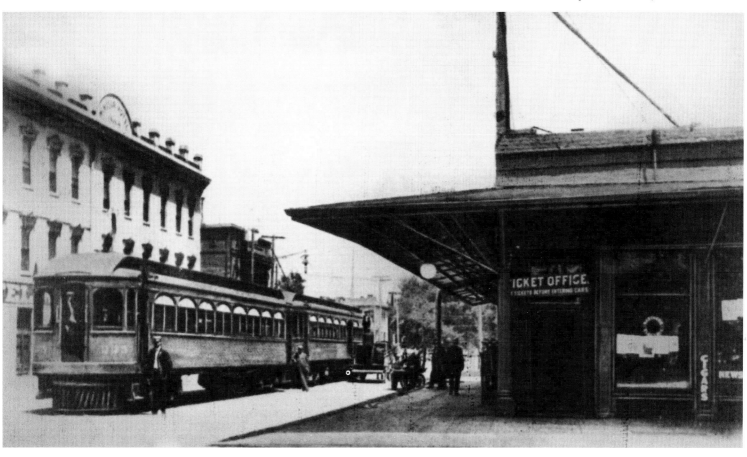

John Breuner Company at 6th and K streets (ca. 1900)

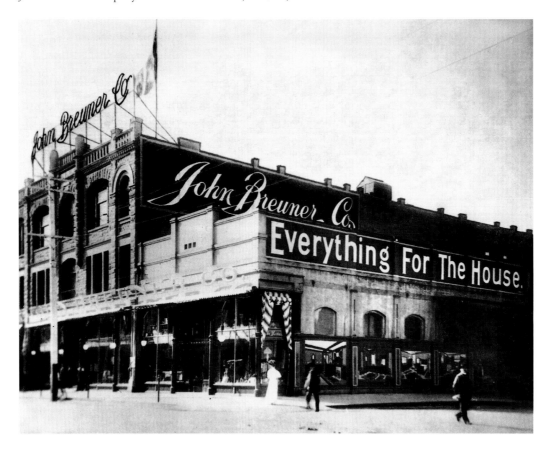

California National Bank at J
and 4th streets (ca. 1910)

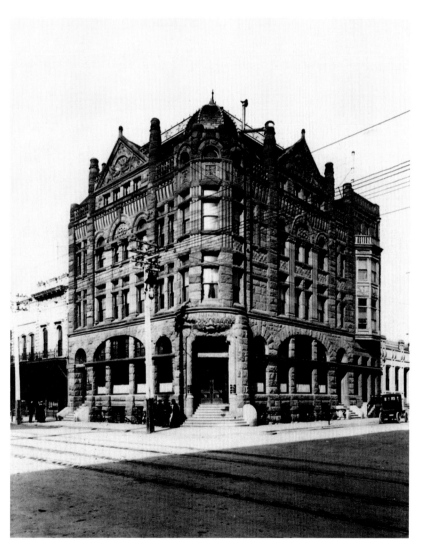

Sacramento Gas and Electric Railway Co. Station "A" Building, at 6th and
H streets (ca. 1904)

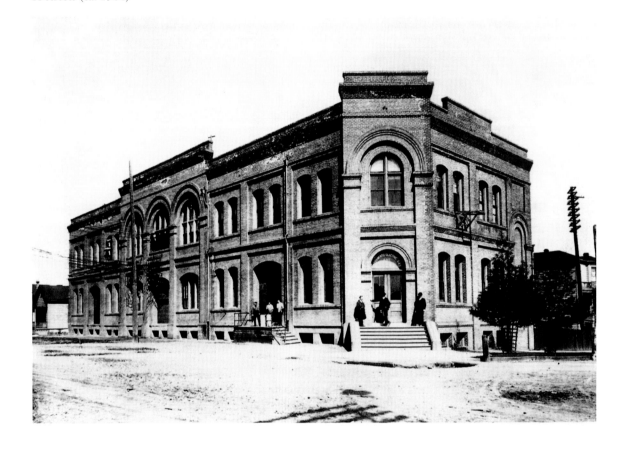

Sacramento Gas and Electric Railway Co. Car Barn at 28th Street between M and N streets (ca. 1904)

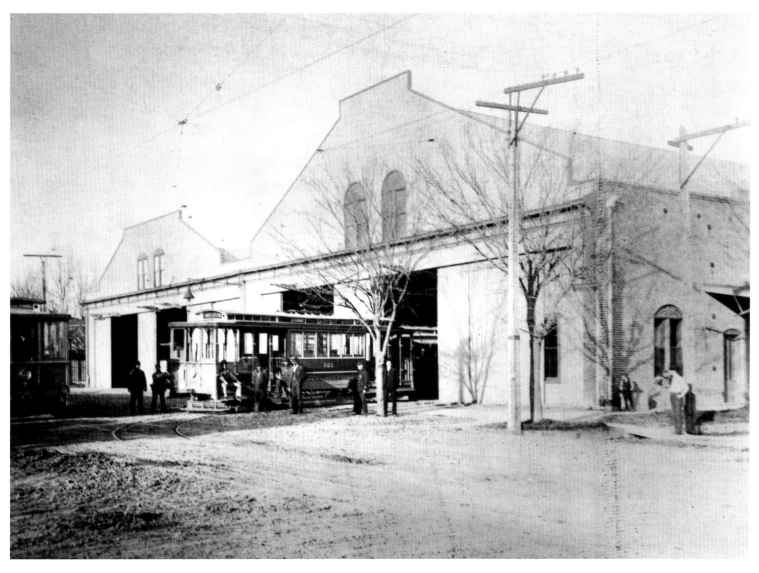

Southern Pacific (previously Central) Depot at I Street (ca. 1904)

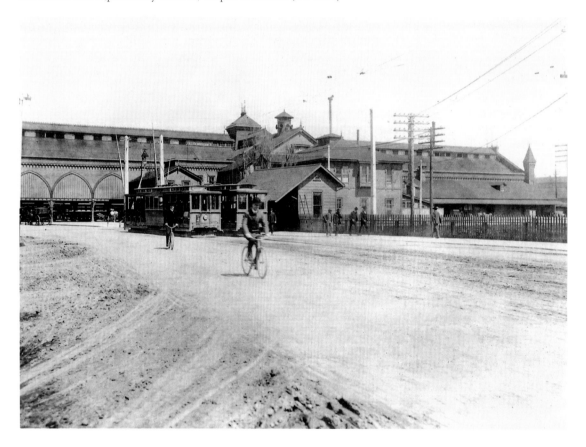

A view of the "Becker & Foster, Oak Park Real Estate, Fire Insurance" business (ca. 1900)

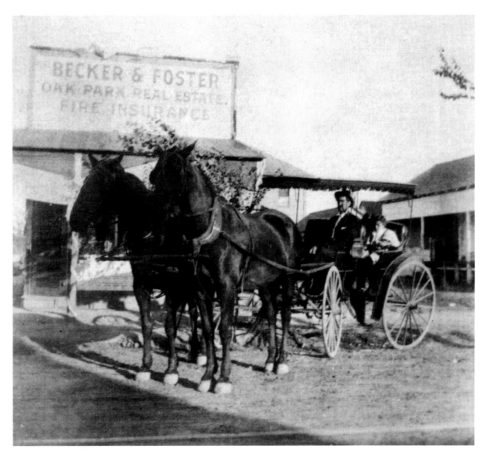

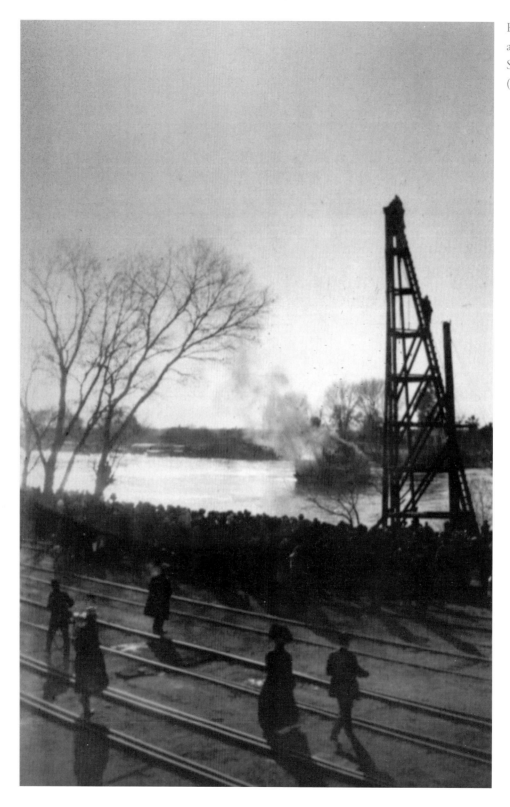

Fireboat demonstration
at I Street and the
Sacramento River
(ca. 1909)

Street crowd (ca. 1915)

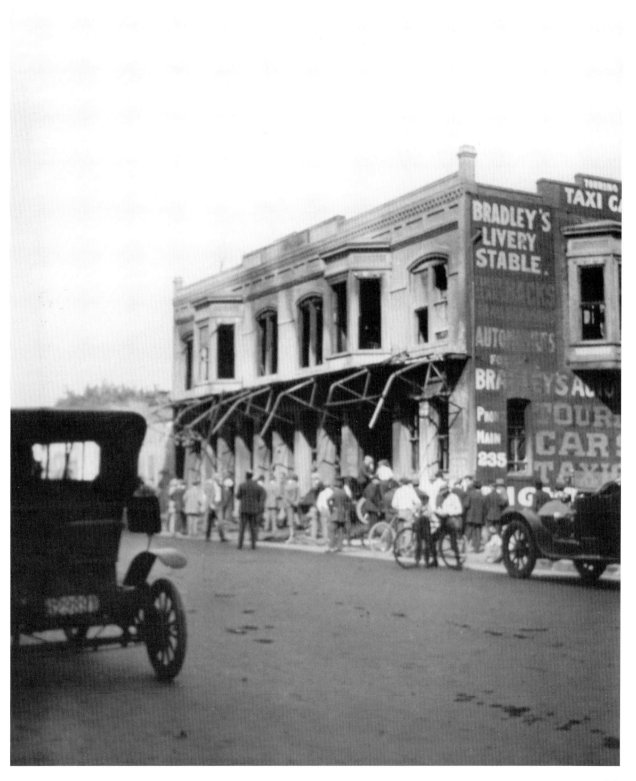

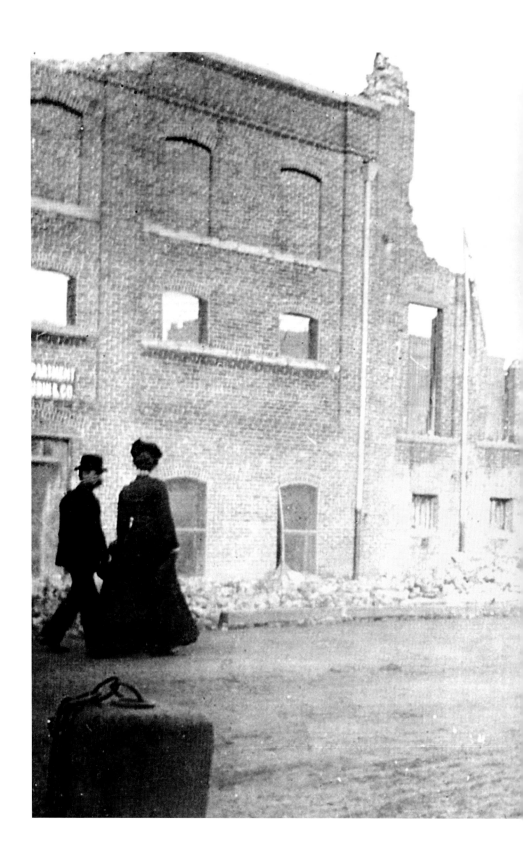

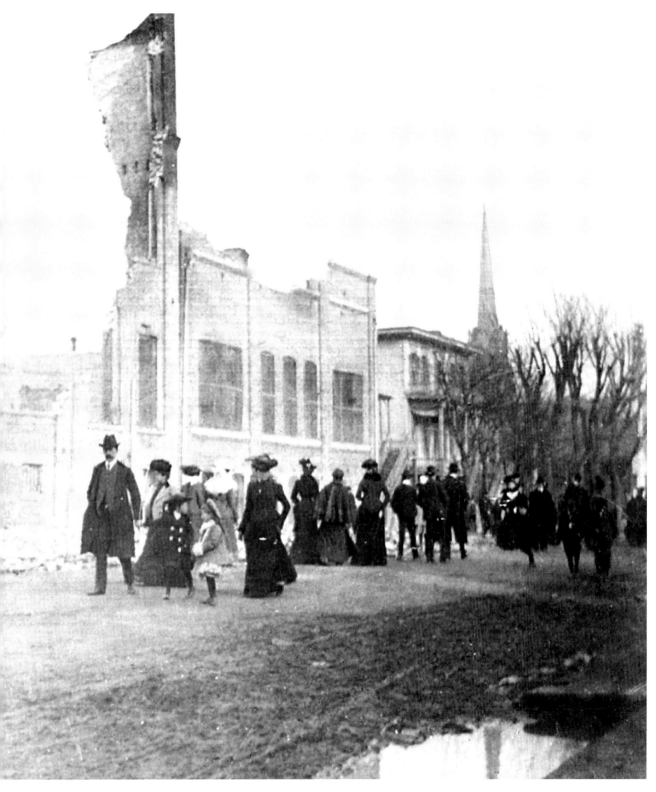

The rubble of Weinstock's Store at 4th and K streets after a fire (ca. 1903)

Fire engine in a parade at J Street (ca. 1916)

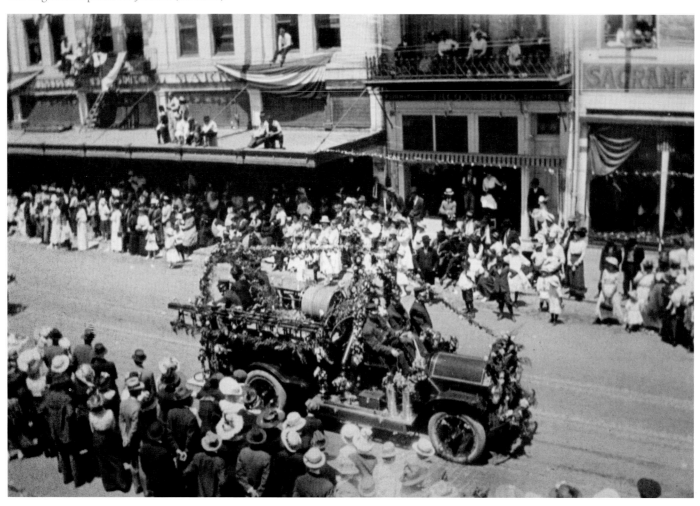

Fire Department Engine Co. in downtown Sacramento

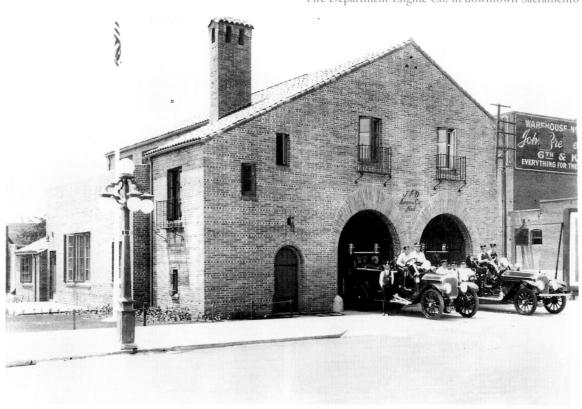

A view of J Street (ca. 1909)

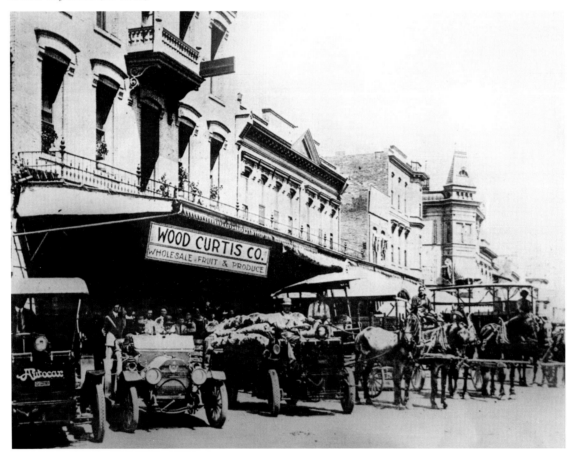

Motorcyclists in front of the Lyric Theatre at 6th Street (ca. 1911)

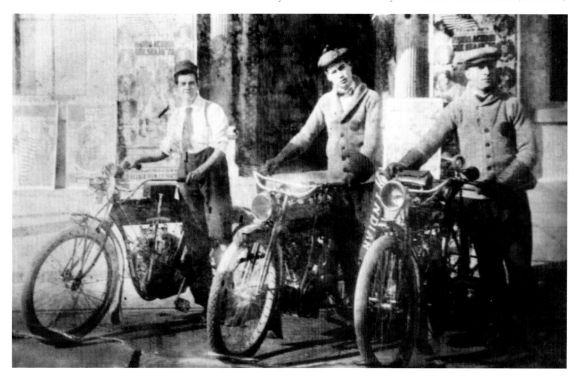

View of K and 8th streets (ca. 1912). United Cigars and the Ambrosia
Cafeteria are visible.

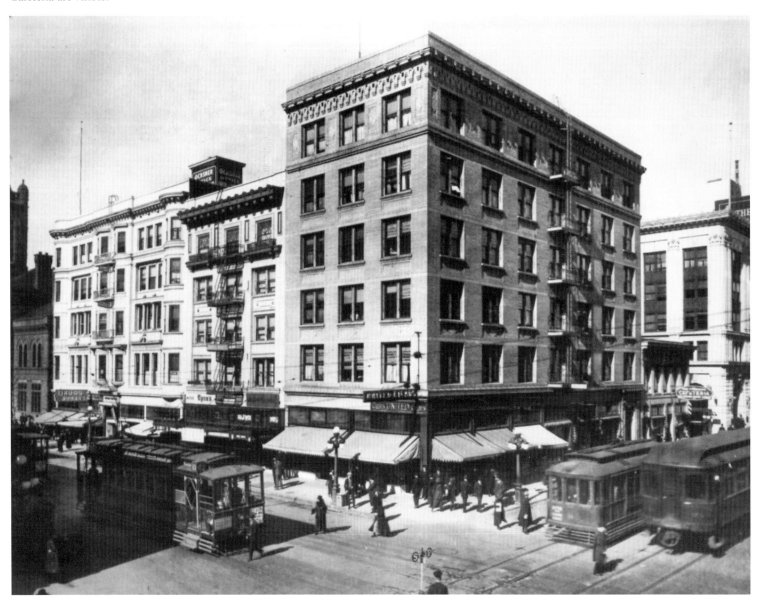

Southern Pacific Bridge over the Sacramento River (ca. 1915)

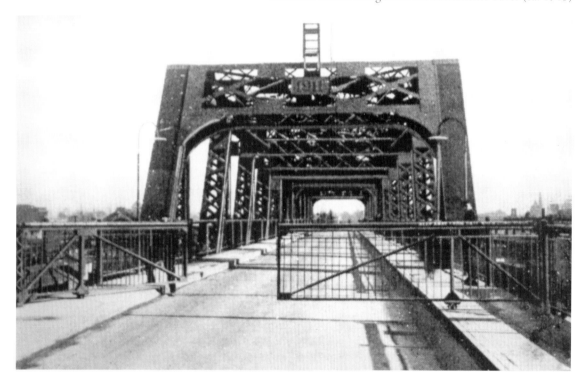

Shipping scene on the Sacramento River (ca. 1915)

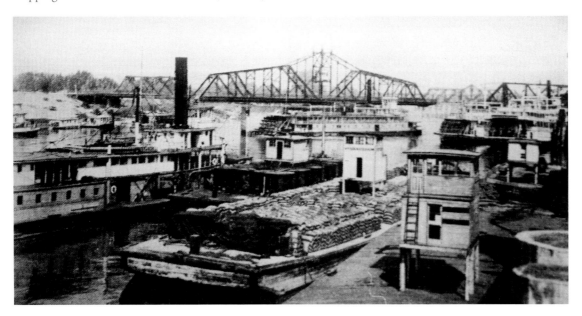

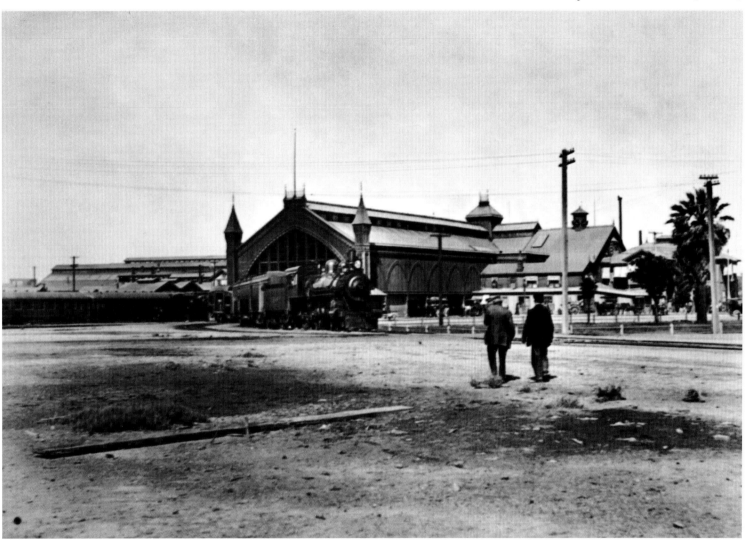

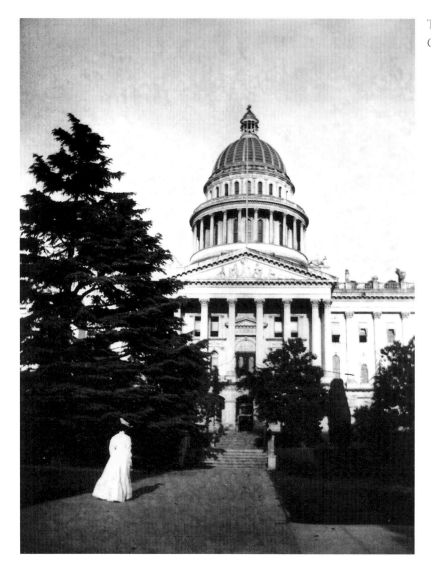

The California State
Capitol (ca. 1910)

St. Francis Church at L Street (ca. 1911)

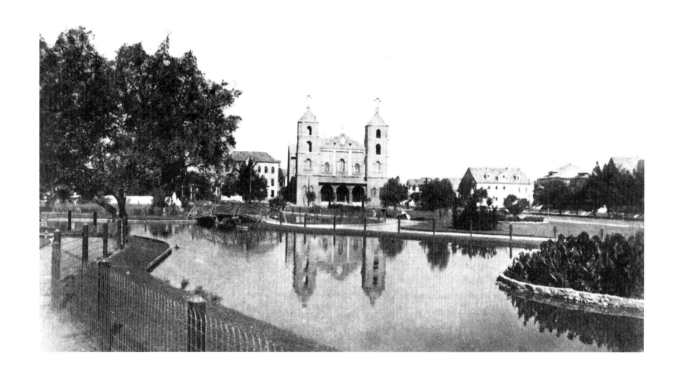

Businesses on J Street (ca. 1915)

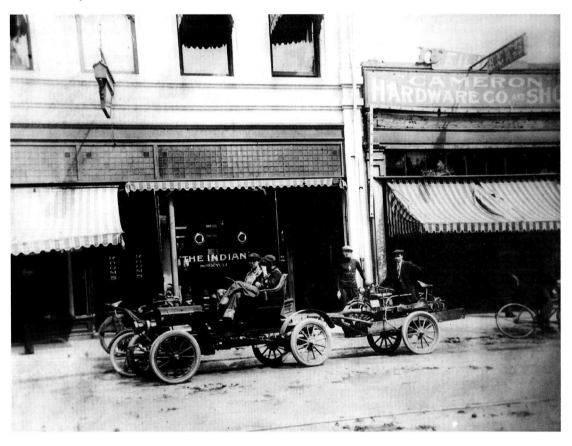

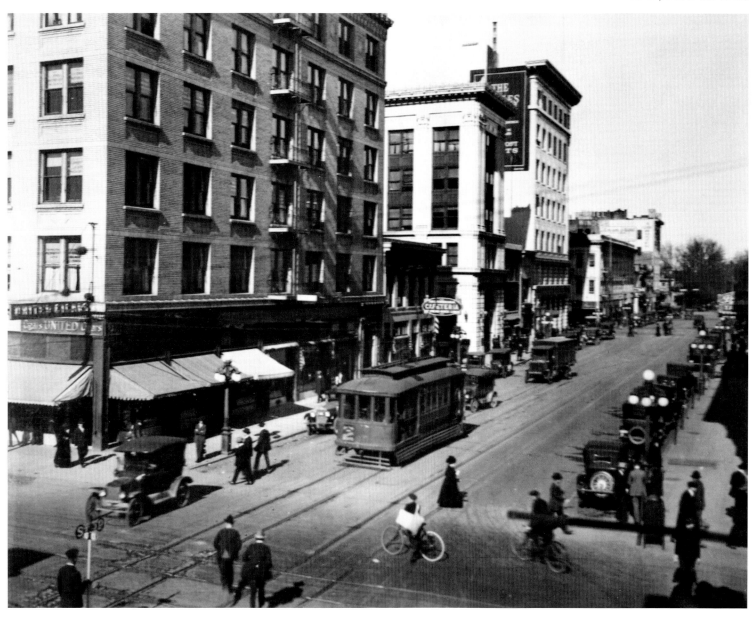

A view of J Street (ca. 1912)

Street fair at K and 9th streets (ca. 1905)

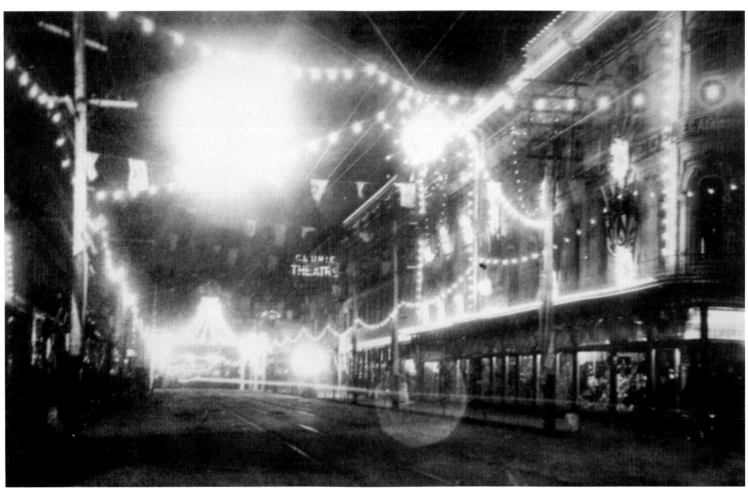

View of K Street (ca. 1908). The U.S. Post Office is visible on the right.

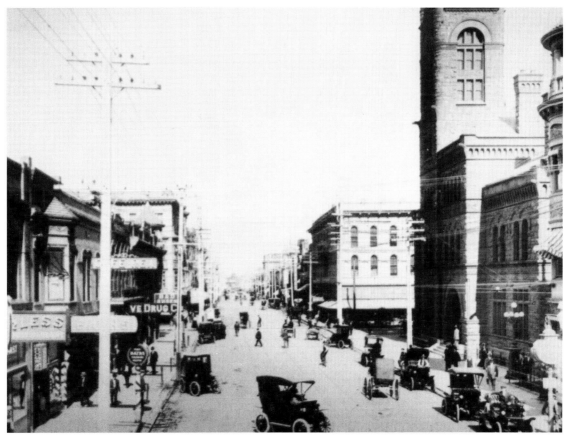

Boats on the Sacramento River during "Sacramento Day" (ca. 1909)

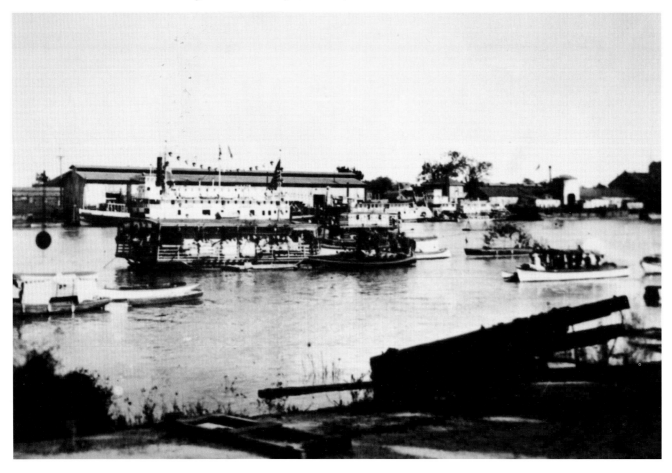

Liberty Iron Works (ca. 1917)

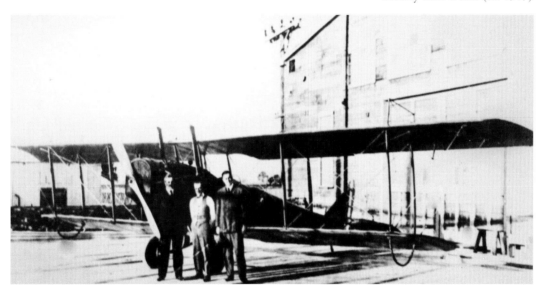

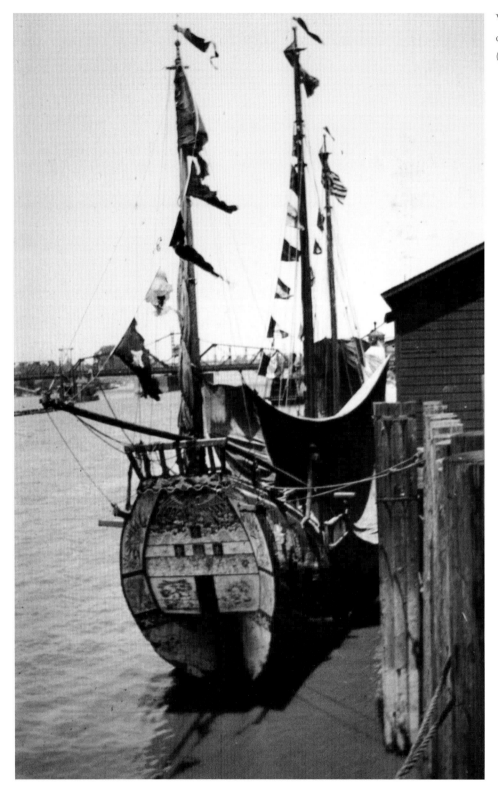

View of a sailing vessel
on the Sacramento River
(ca. 1914)

Peerless Ice Cream wagon in a parade at J Street (ca. 1916)

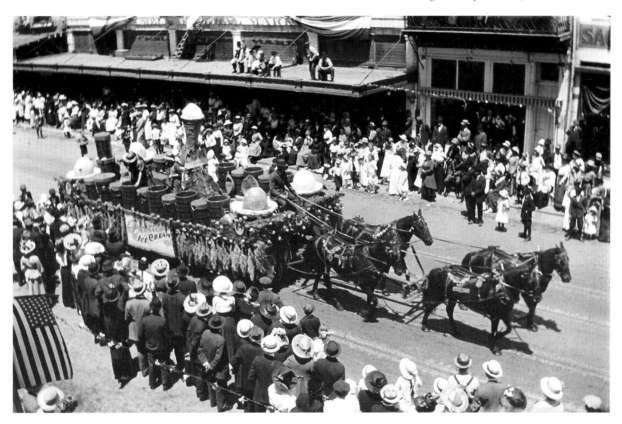

A Capital City Wheelmen Club race at the
agricultural park (ca. 1900)

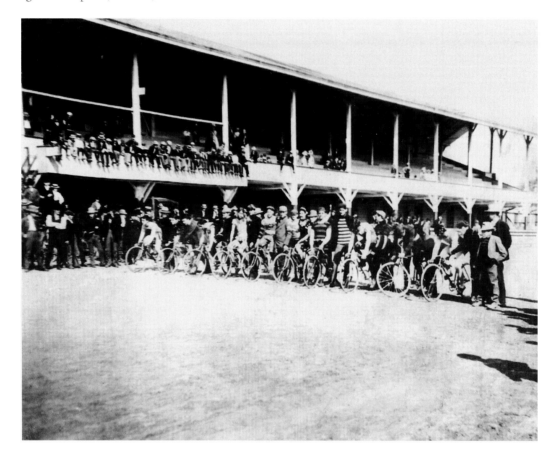

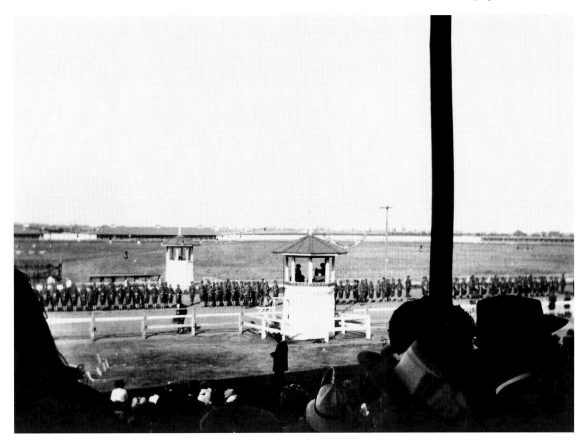

View of the racetrack at the
"Sacramento Day" parade (ca. 1909)

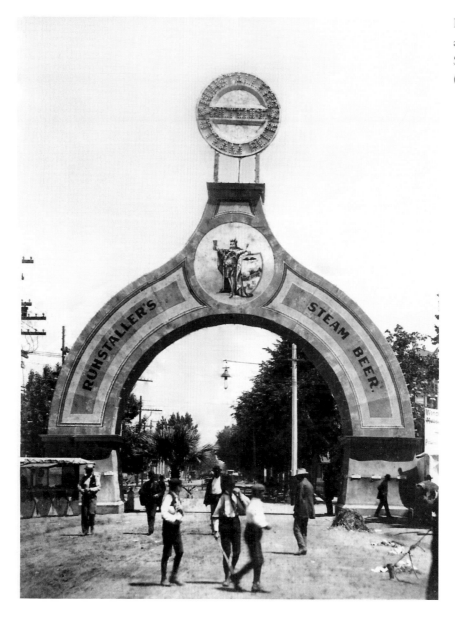

Ruhstaller's Steam Beer
advertising sign at the
Sacramento street fair
(1904 or 1905)

Train engine entertainment at the California state fair (ca. 1917)

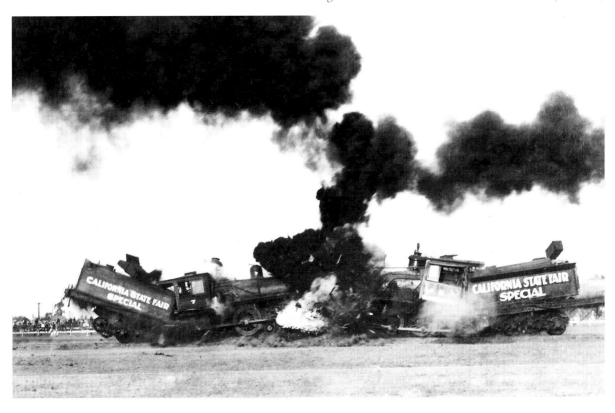

The Sacramento skyline (ca. 1905)

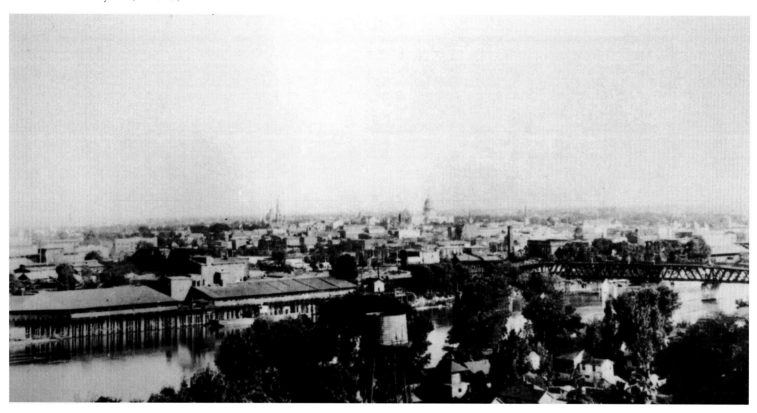

A delivery wagon carries Buffalo Brewery beer kegs at 12th and H streets at the I Street bridge.

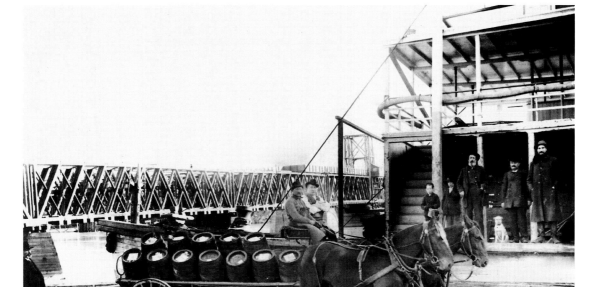

Street scene at J Street

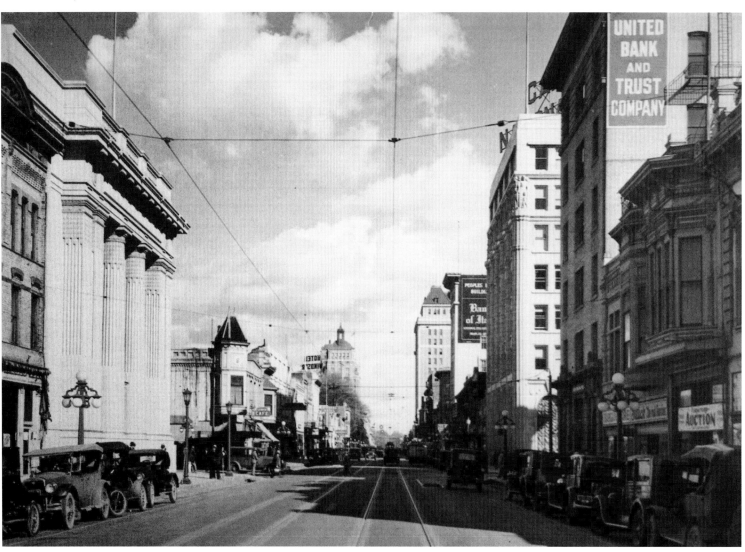

The "Wells Fargo & Co. Express, Denver and Rio Grande Express"
at H Street (ca. 1900)

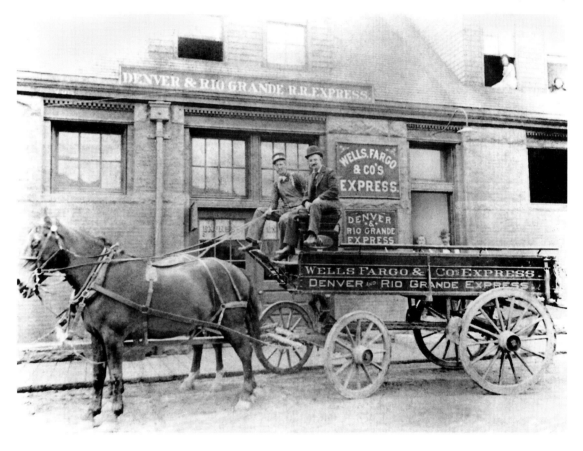

Sacramento City Hall and City Park

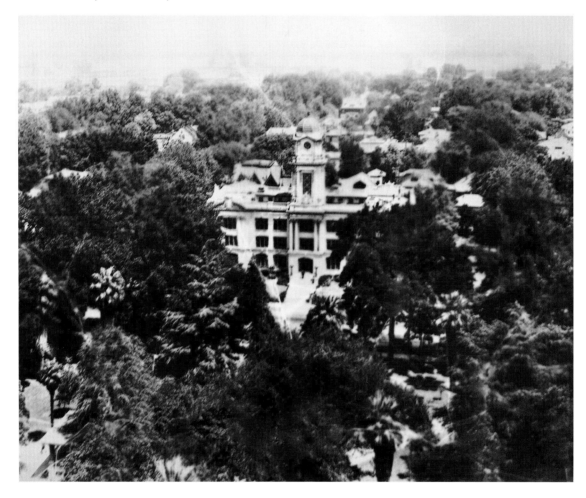

A City Joining the Nation

1918–1939

Whatever rustic idyll Sacramento enjoyed early in the century was shattered with the start of World War I. The city nonetheless stepped forward, joining the rest of America in sending its daughters and sons to join the workforce at home or fight overseas. Returning servicemen faced radical changes in a city both reeling from the Spanish influenza epidemic and loosening up as Prohibition became the law in 1920 for the area's 87,000 residents. The postwar building boom and free-wheeling economy placed Sacramento on the same roller-coaster ride as the rest of the nation, a giddy spree that marked a new direction in construction and development, transportation, and the pursuit of pleasure.

Landmarks sprang up during the next decade, with 20 public and business buildings amounting to $13,245,000, starting in 1925 alone. The same year, more than 1,100 new homes mushroomed upward in brand-new developments. Long-term associations with brand-name enterprises like Coca-Cola and Harley-Davidson were established. Stables and horse-drawn vehicles, still visible in 1920, were an anachronism by 1930, replaced by filling stations and garages to keep the flow of automobiles coursing over 235 miles of paved roads. There were 31,000 telephones in service. Trees dotted the landscape everywhere.

Neon lights flashed the names of local businesses, theaters, and hotels over the heads of consumers on the move. It was a time of parades for heroes like Charles Lindbergh. Visitors arrived by rail and riverboat, using the city's ever efficient system of streetcars, which covered 14 square miles in steel grids.

Just as Sacramento joined the rest of the nation in its dizzying upward spiral, it fell with the same velocity when the Great Depression hit in 1929. Work projects sponsored by federal programs put food on the table for local families. Two new airbases provided further employment and a key to the future, while two iconic symbols of the city, the $994,000 Tower Bridge, linking Sacramento to Yolo County (1935), and the Tower Theater (1938), opened to enthusiastic crowds yearning for something to celebrate.

Baseball, parks and playgrounds, the state fair, and double-feature movie houses kept citizens entertained, monuments kept past accomplishments relevant, the danger of fire and flood kept residents on their guard, and an American flag in a parade still brought Sacramento's now 121,000 residents to their feet as 1939 came to a close.

Coca Cola Bottling Co. on Sacramento Blvd. (ca. 1928)

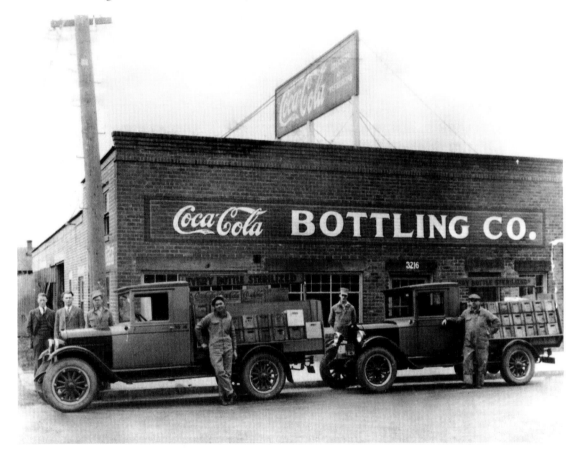

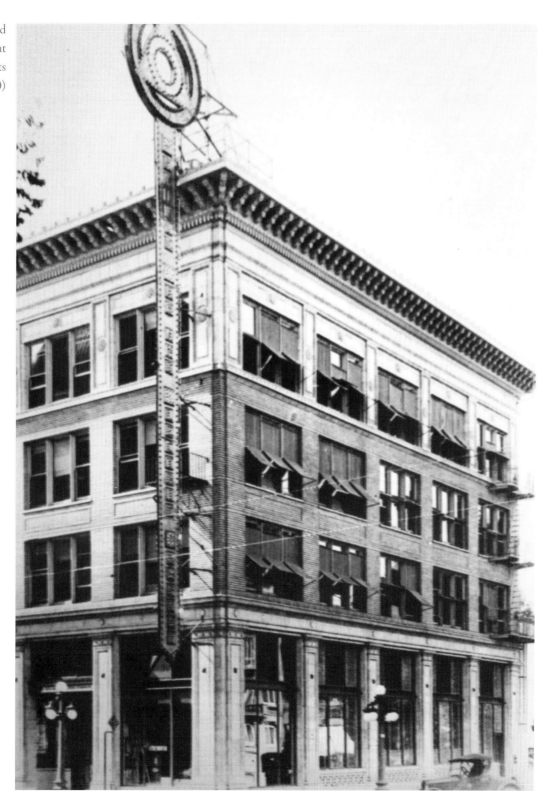

Pacific Gas and Electric Building at 11th and K streets (ca. 1930)

Flood scene at J Street

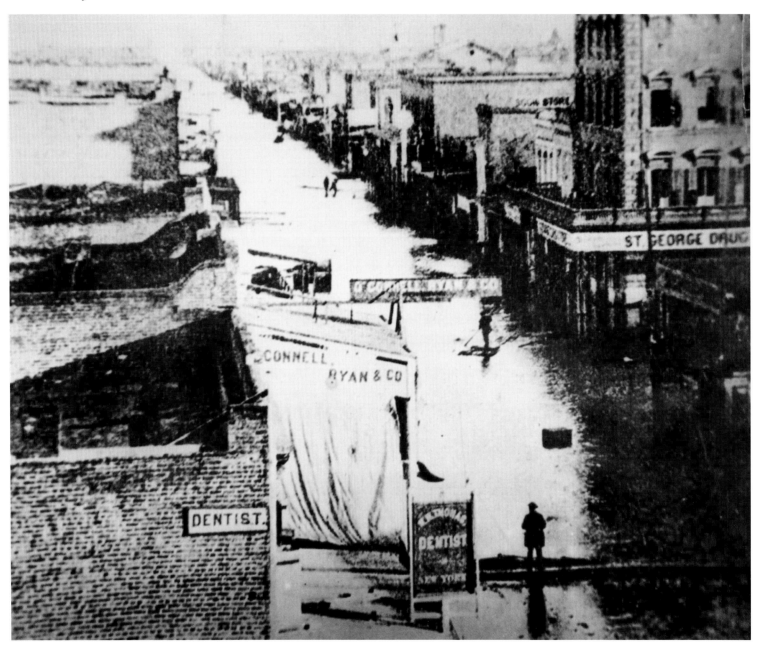

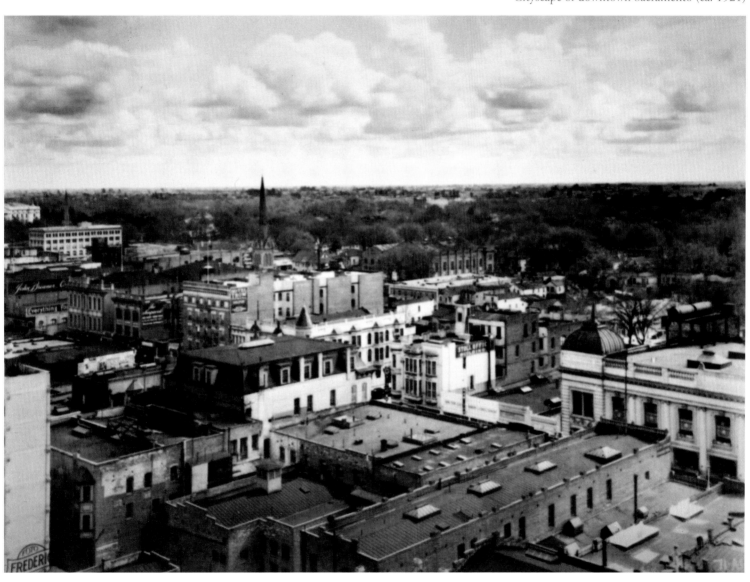

Cityscape of downtown Sacramento (ca. 1921)

St. Rose of Lima Church at
7th and K streets

Street scene at 10th and K streets (ca. 1925). Cathedral of the Blessed Sacramento and Mohr and Yoerk Market are visible to the left, the Hotel Sacramento to the right.

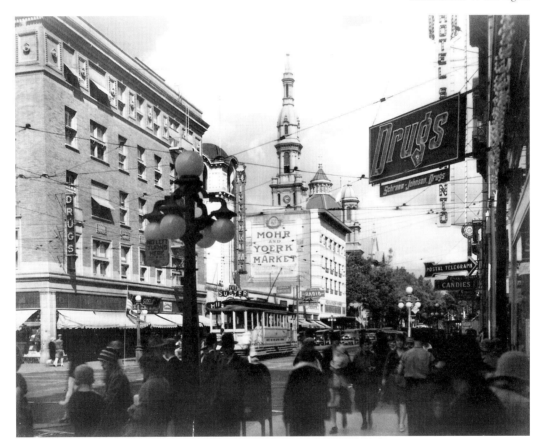

Post Office at 7th and K streets (ca. 1920)

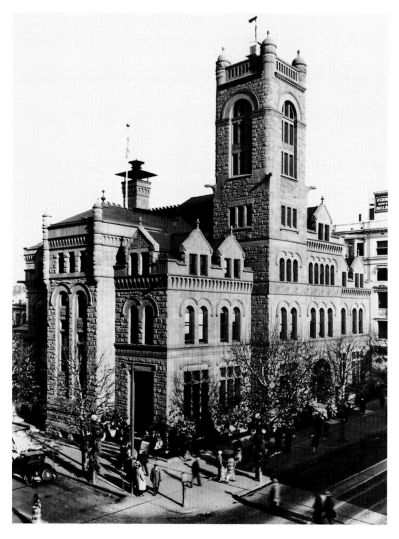

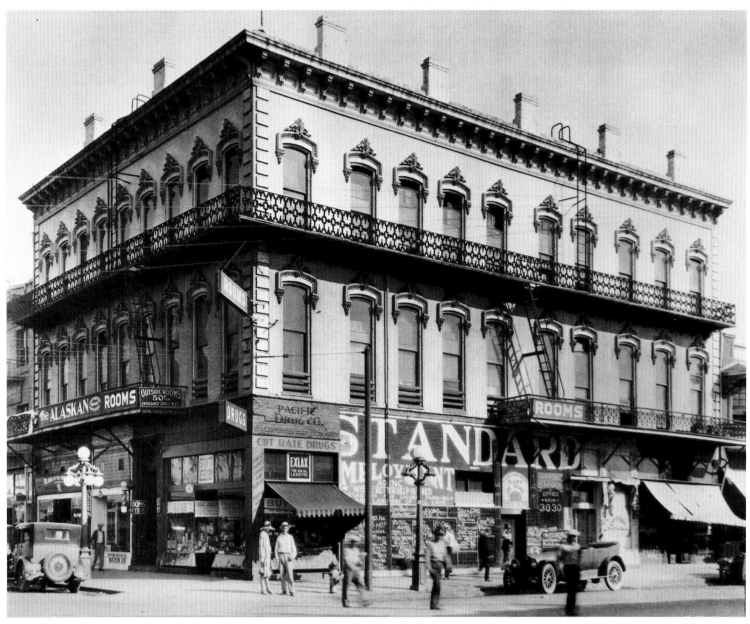

View of the Fratt Building at the corner of 2nd and K streets (ca. 1928). The Standard Employment Agency, Pacific Drug Co., and Alaskan Rooms are visible.

Cityscape at 9th and K streets (ca. 1920). The capitol building is visible to the left and capitol extension building (now the state library and courts building) is under construction to the right.

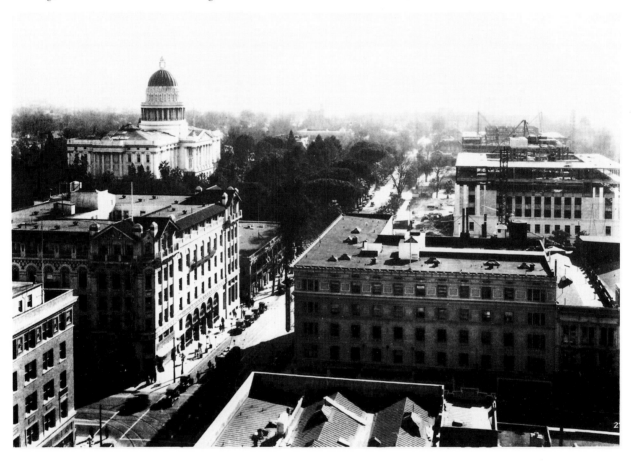

The California state capitol
building (ca. 1922)

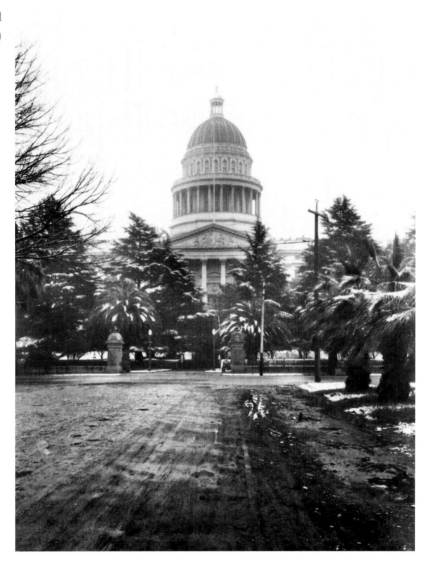

The state capitol building and cityscape (ca. 1920)

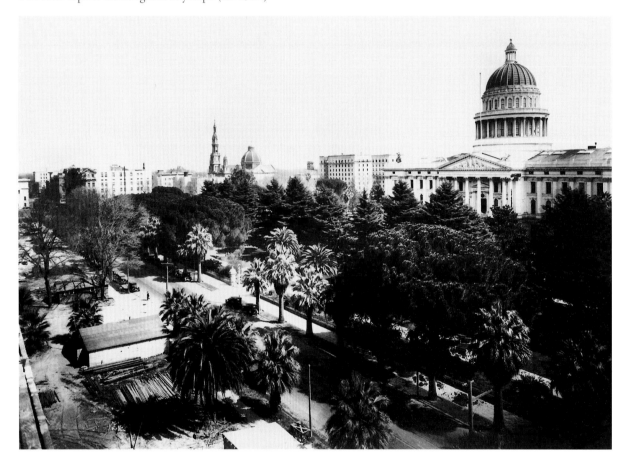

Parade at K Street (ca. 1920). Post Office and Eaglesons Clothing Store are visible.

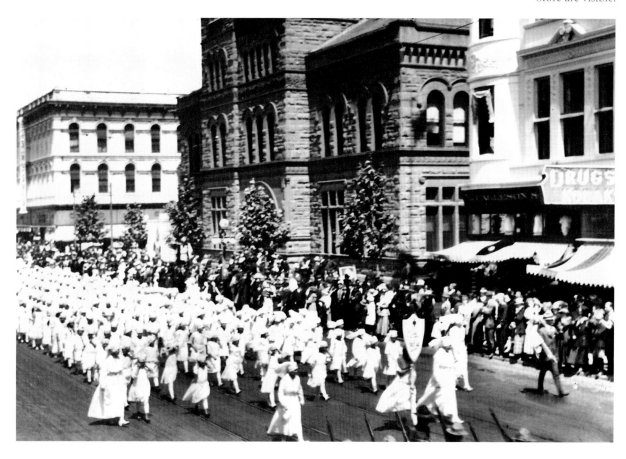

Fire engine at L Street (ca. 1924)

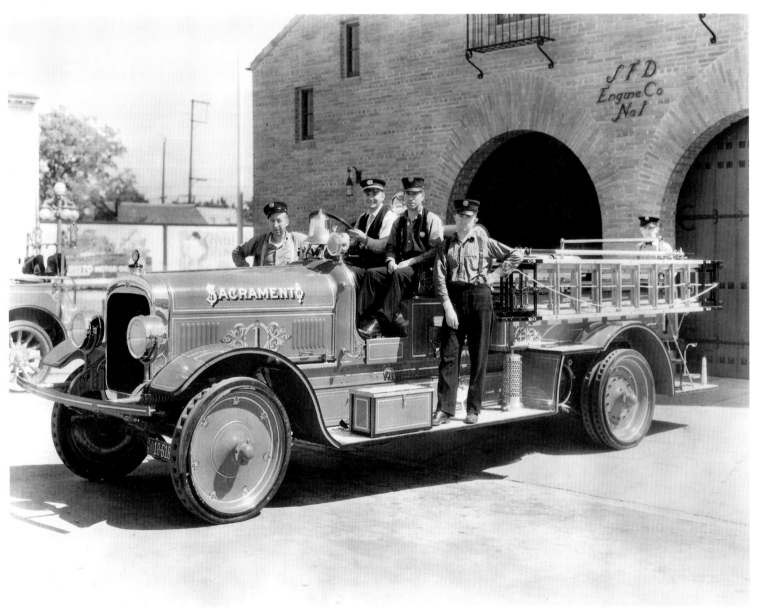

Elks building at J and 11th streets (ca. 1928)

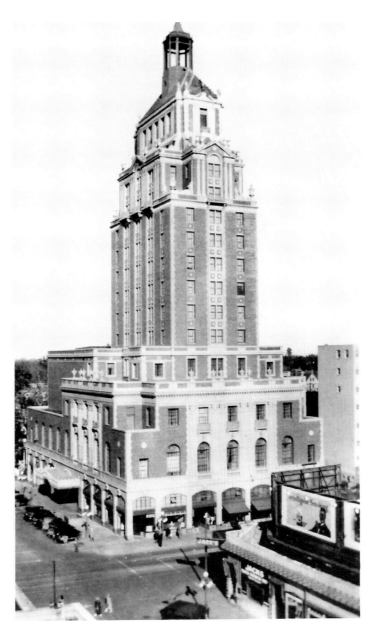

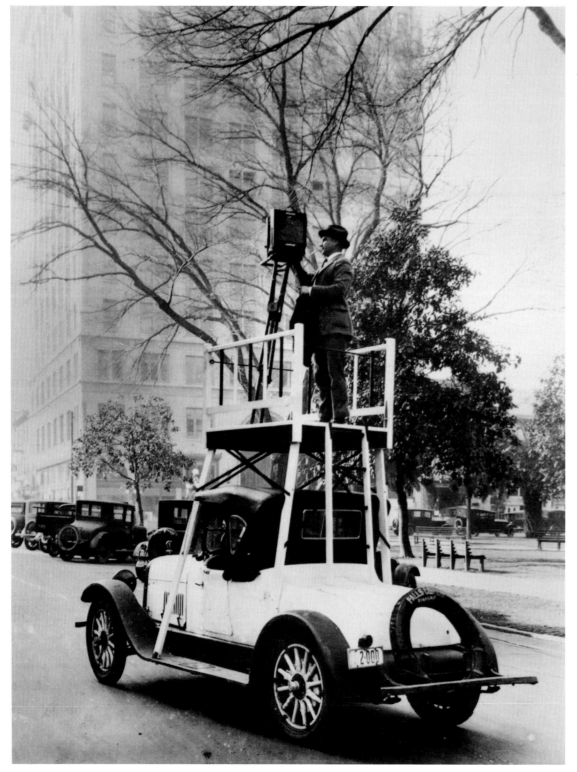

McCurry Co. car fitted with a camera platform on 10th Street between I and J streets (ca. 1924). The Plaza Park and Western States Life Building is visible.

State fair races at Stockton Blvd. (ca. 1926)

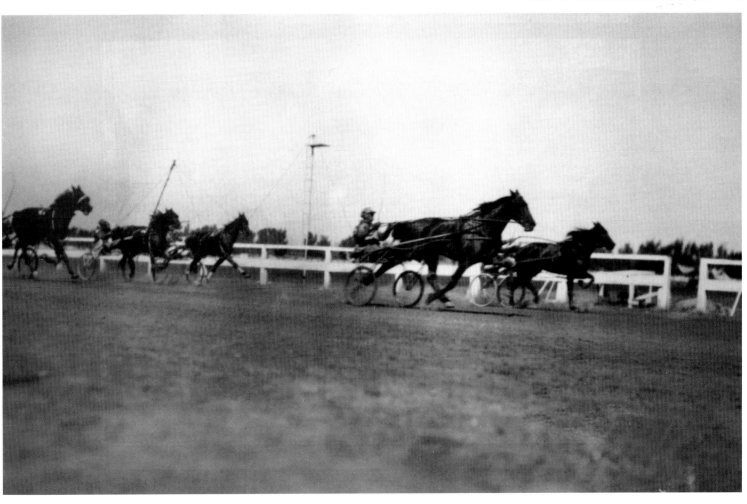

The *Delta King* steamer on the Sacramento River during 4th of July festivities (ca. 1929)

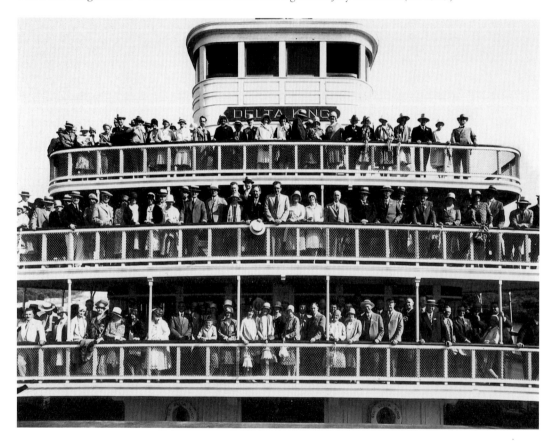

Photo shoot in front of Red Cross offices at 8th Street (ca. 1924)

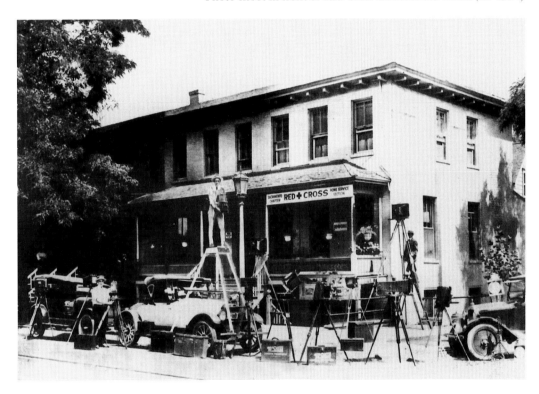

Charles Lindbergh speaks to Sacramento citizens. (ca. 1927)

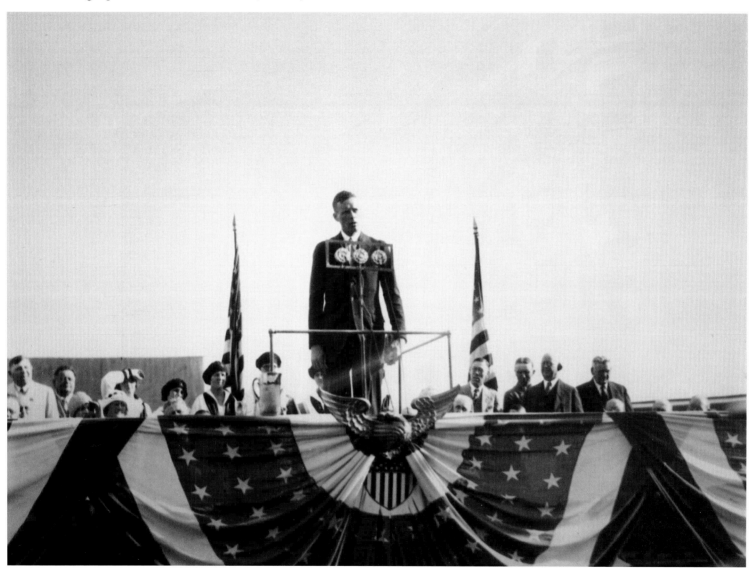

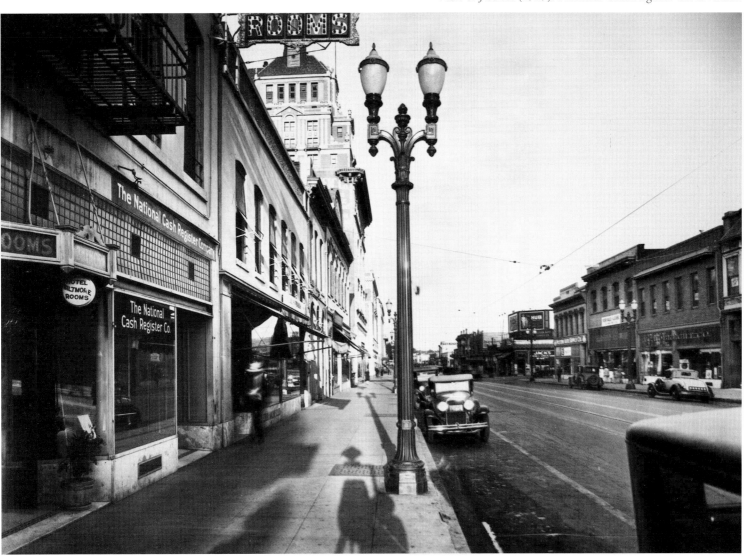

View of J Street (1929). National Cash Register Co. is visible.

Motorcycles advertise the Harley Davidson Store on J Street. (ca. 1924)

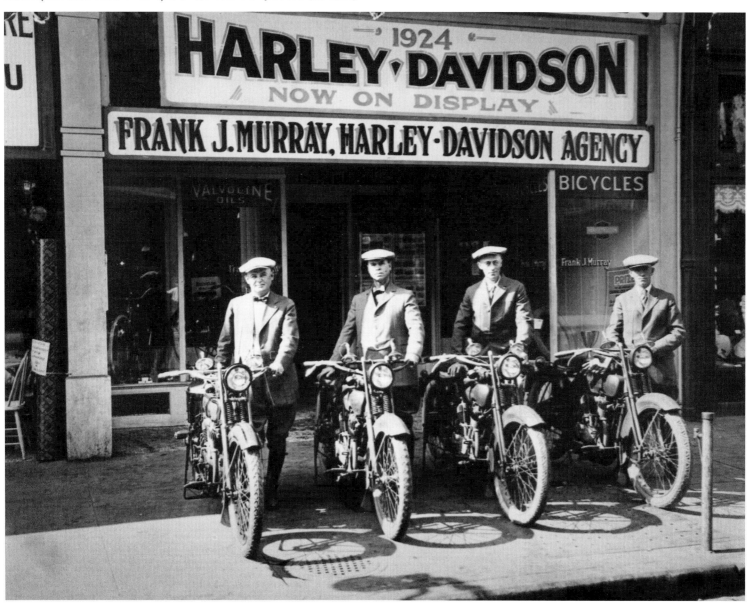

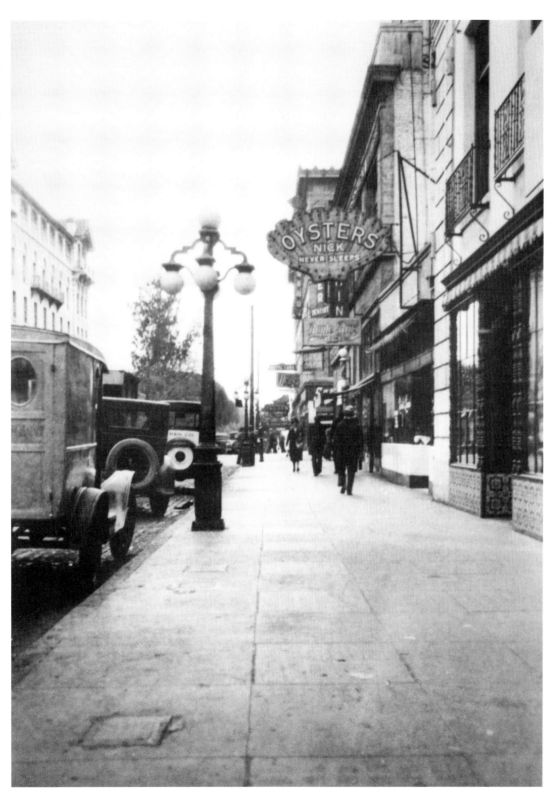

A view of 10th Street (ca. 1929). Restaurant sign says "Oysters, Nick Never Sleeps."

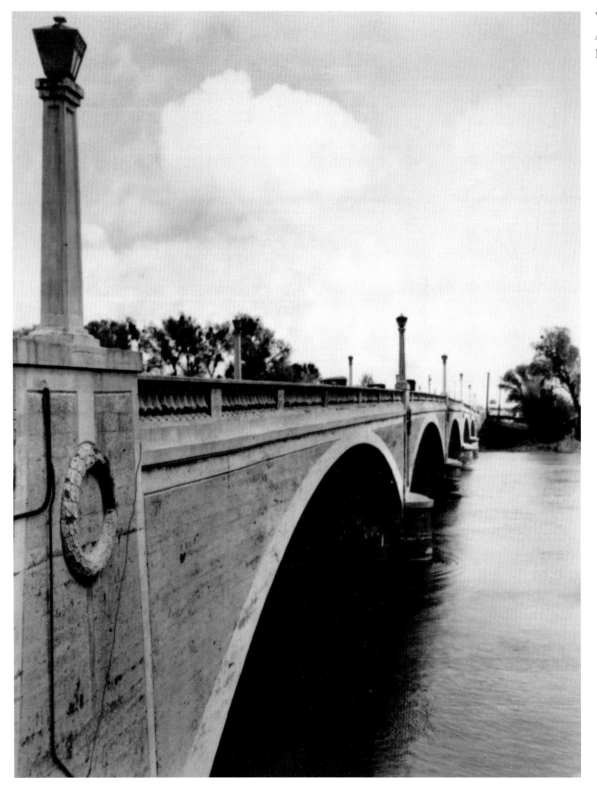

View of the bridge across the American River at N. 16th and N. 12th streets (ca. 1920)

The state library and courts building in the capitol extension group (ca. 1920). On the architrave are the words "Into the Highlands of the Mind Let Me Go."

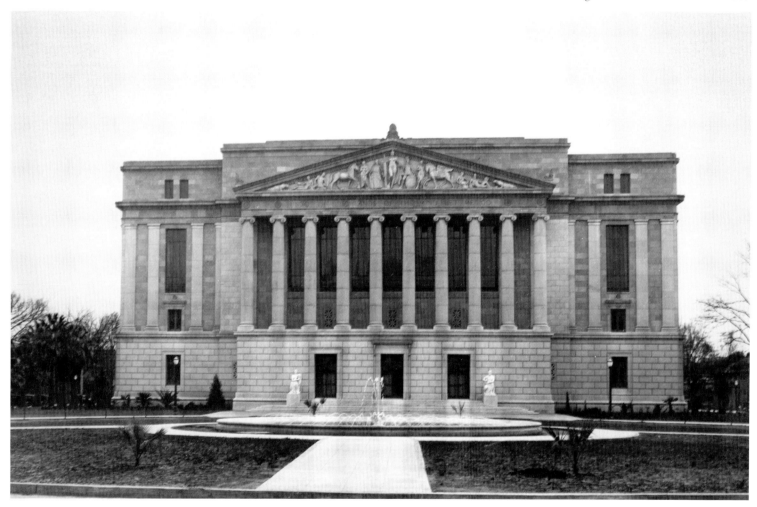

Shown here is the Tim Anspach Mule Co. stagecoach at 30th and R streets. (ca. 1925)

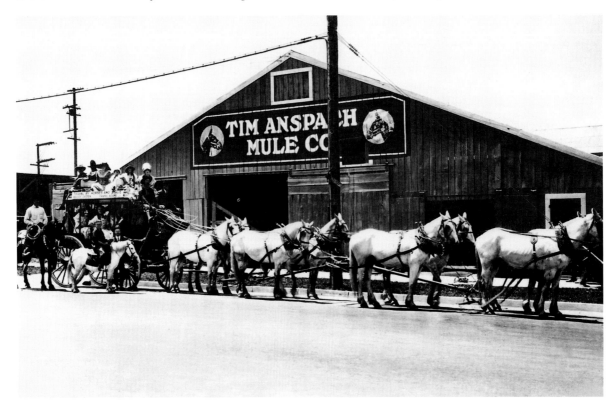

Sacramento Northern Railroad Cars at 8th and K streets (ca. 1925). The train ran from Chico to Sacramento to San Francisco in the 1920s and 1930s, and was the longest interurban electric line in the U.S. (229 miles). Ambrosia Cafeteria is visible to the far left.

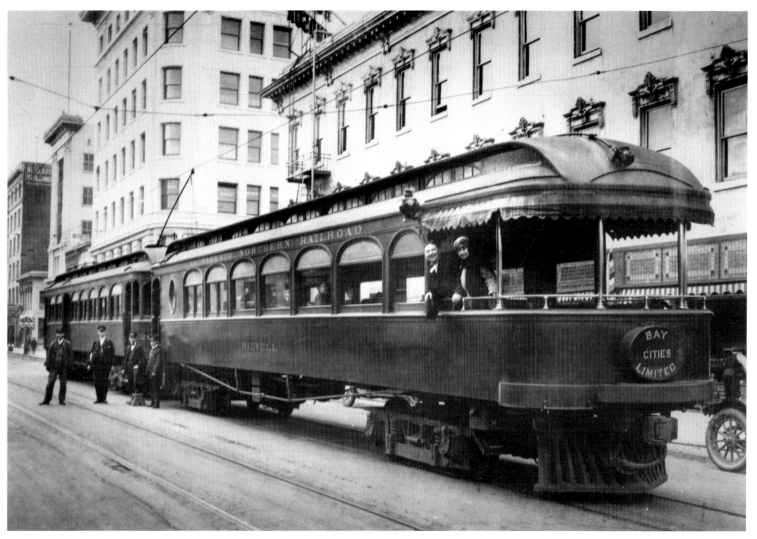

Racing car (1920s)

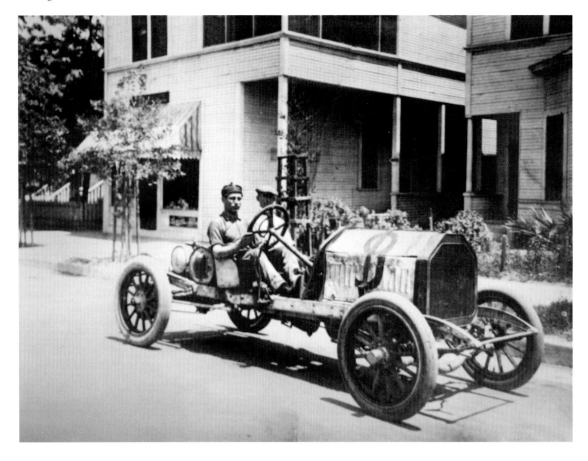

Street scene at 12th and J streets (ca. 1925). Elks Building and State Theater are visible to the right and California Life Building to the left.

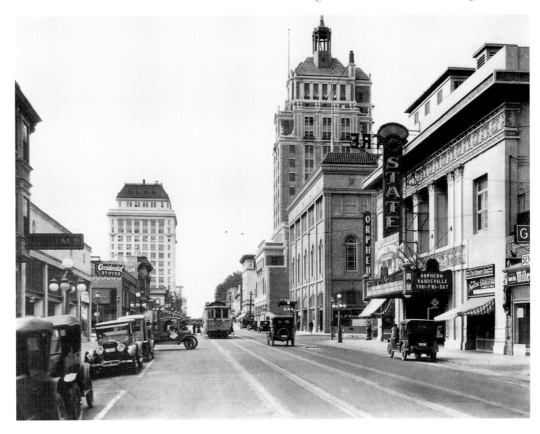

Street scene at 8th and K streets (ca. 1920). Hotel Clunie and Bergman's Hats are visible to the left.

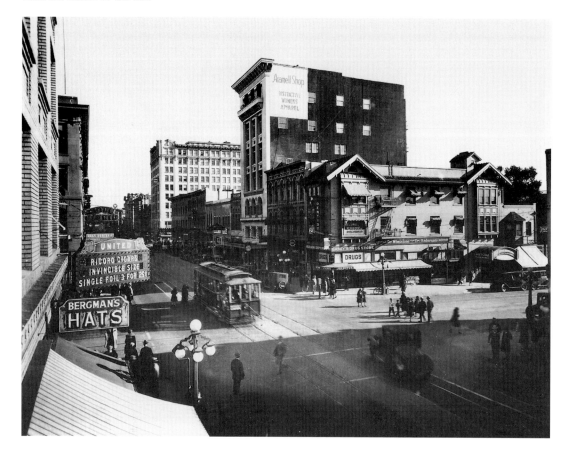

Night view of 10th and K streets (ca. 1920). The Sutter Restaurant is visible to the right and Levinsons Bookstore and Hotel Land to the left.

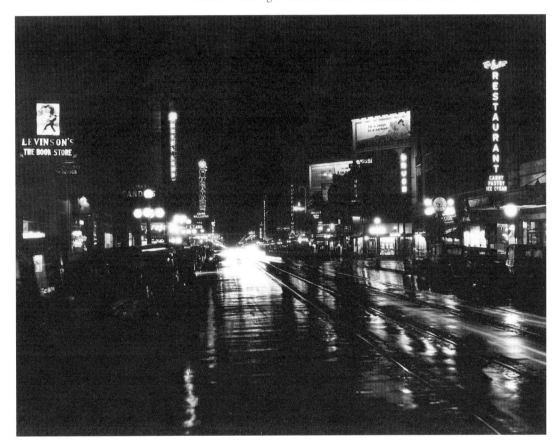

View of J Street (ca. 1922). Bank of Italy (later the Bank of America) is visible in foreground to the right.

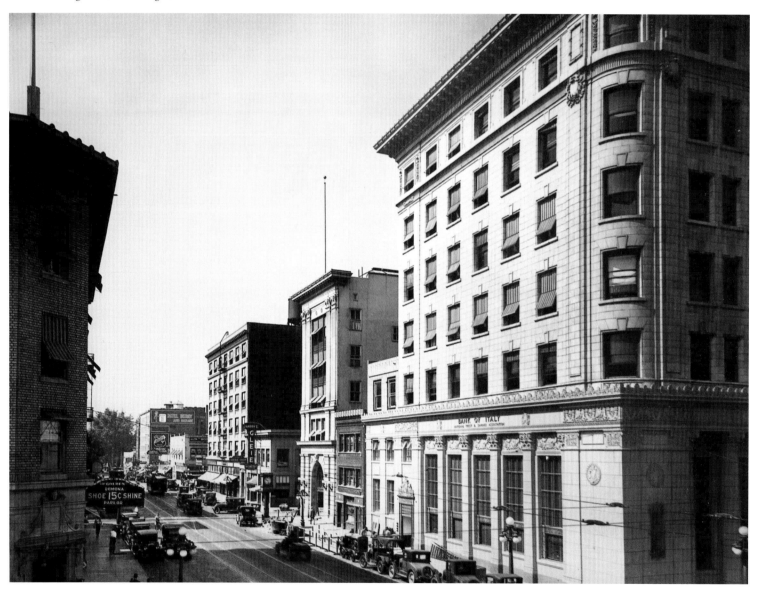

Downtown fire

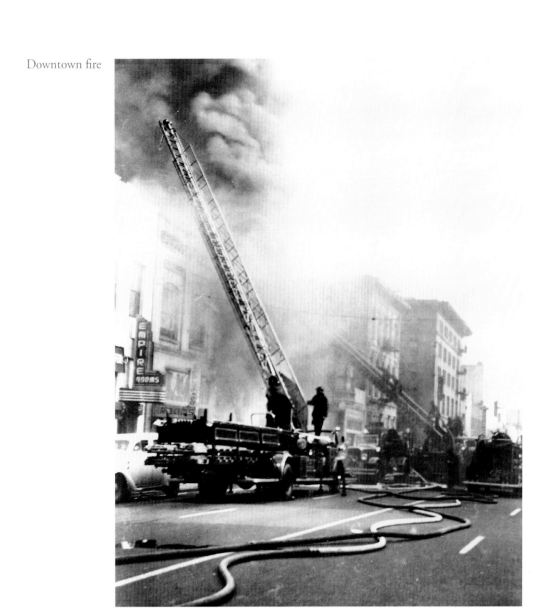

The Osborn and Folger Ice Co. on I Street

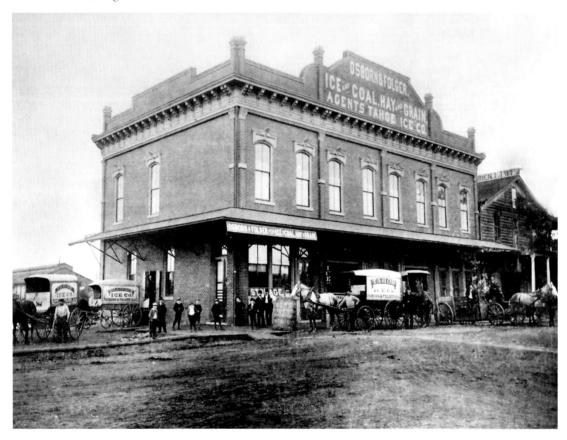

Business on L Street halts to pose for the camera.

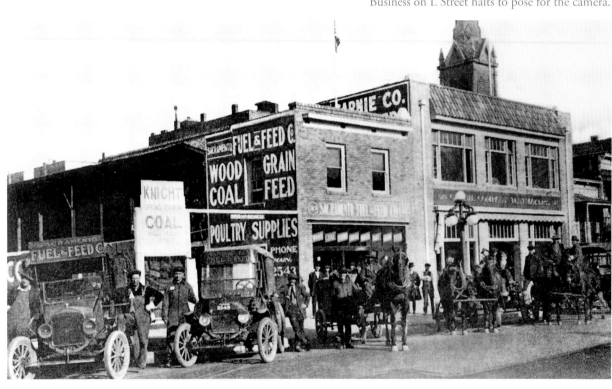

California State Life Insurance
Building (ca. 1928)

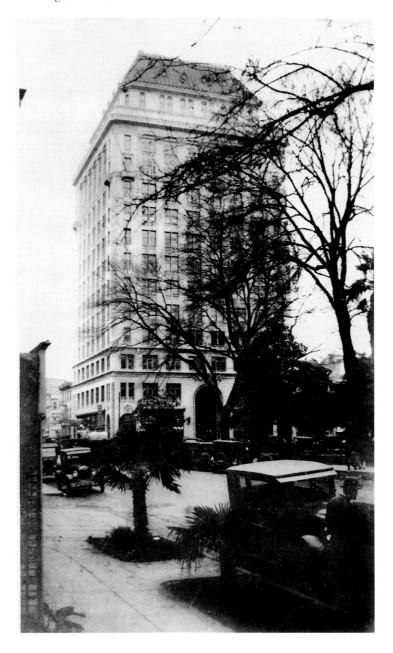

Western Hotel at 3rd and K streets (ca. 1931)

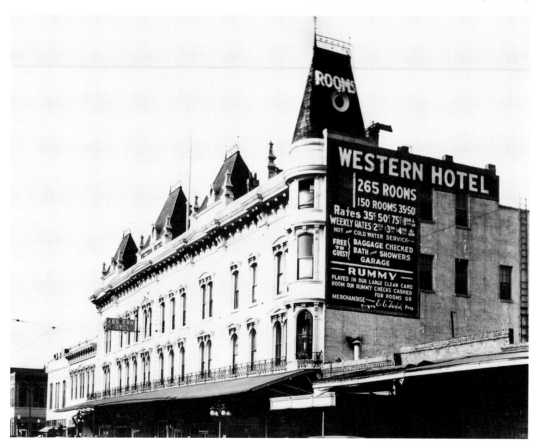

Ben Ali Shriners bands parade down J Street (ca. 1937). Among other businesses, Coast Radio is visible in the Ruhstaller Building, at right.

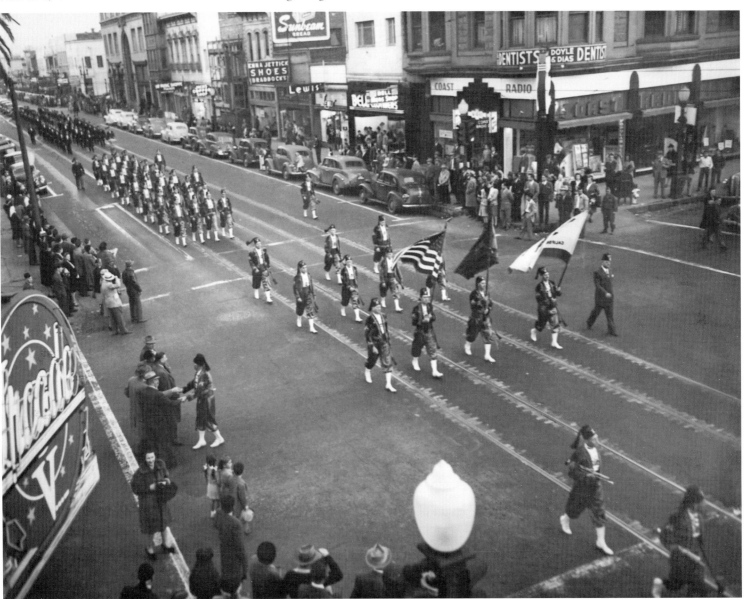

The Dawson House Hotel, built in 1856, at the southeast corner of 4th and J streets (ca. 1938)

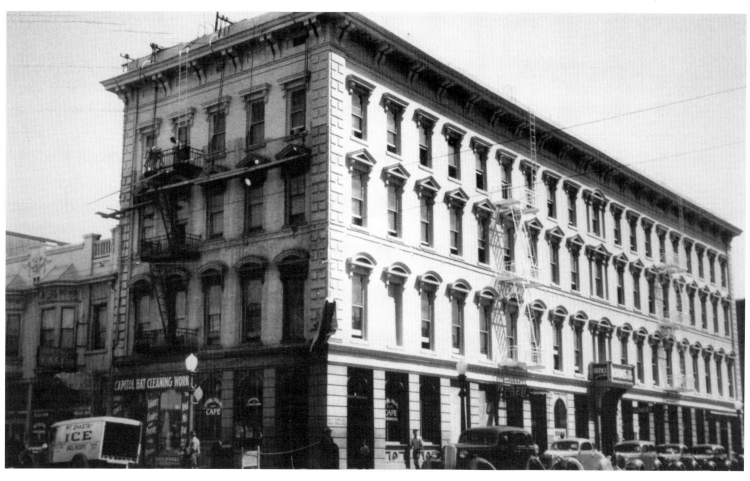

Hotel Sacramento at the northwest corner of 10th and K streets (ca. 1930)

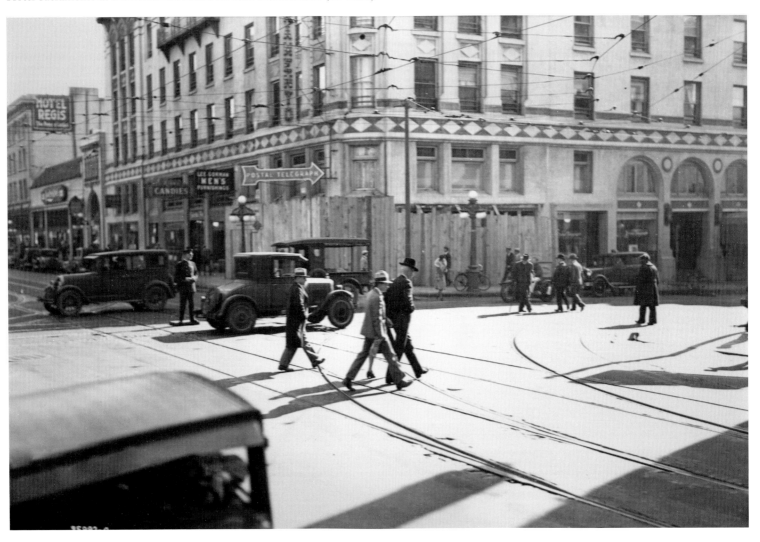

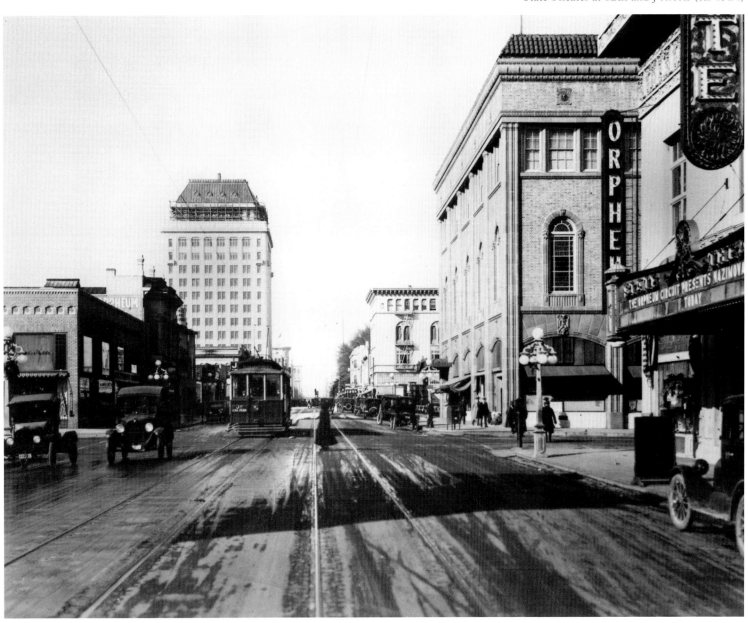

State Theater at 12th and J streets (ca. 1924)

View of J Street (ca. 1926). State Theater and Elks Club are
visible to the right and California Life Building to the left.

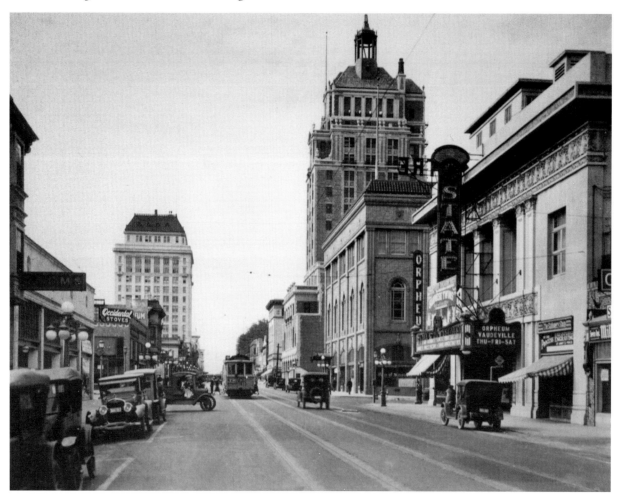

A marching band participates in the opening of
Tower Bridge. (ca. 1935)

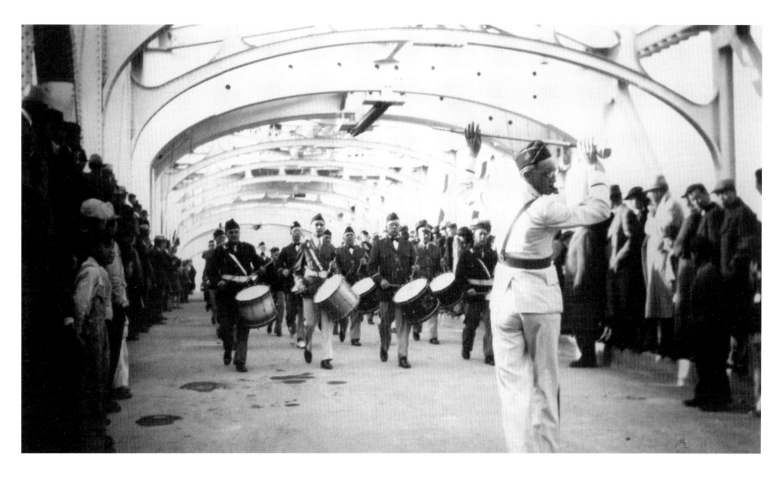

View of K Street

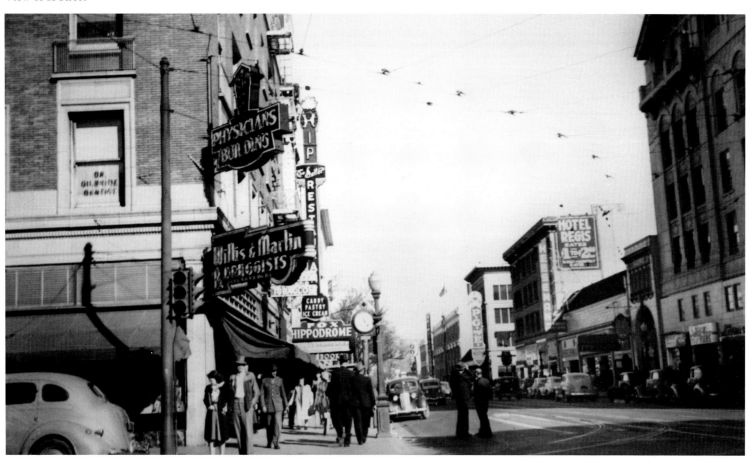

The National Bank of D. O. Mills at 7th and J streets is visible in this rooftop view. (ca. 1925)

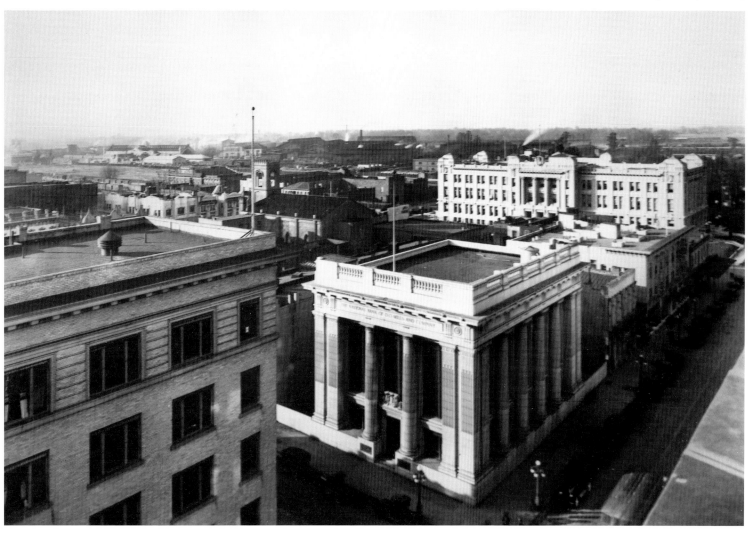

Sacramento Baseball Team at Edmond's Field (ca. 1935)

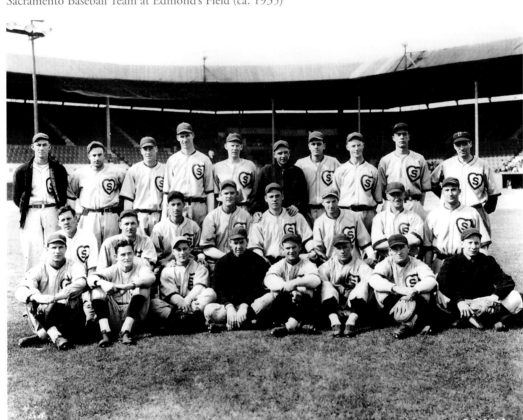

Downtown Sacramento (ca. 1939). The tower of the Church of the Blessed Sacrament is visible in front of the Elks Club tower.

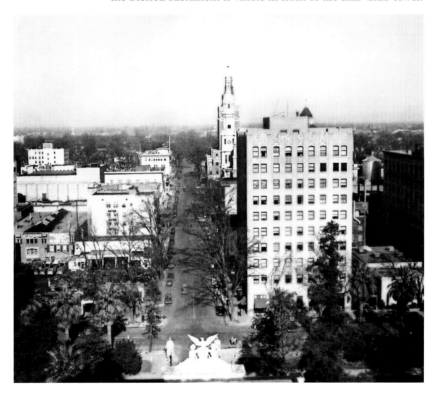

Aerial view of the capitol building and the surrounding downtown area (ca. 1930)

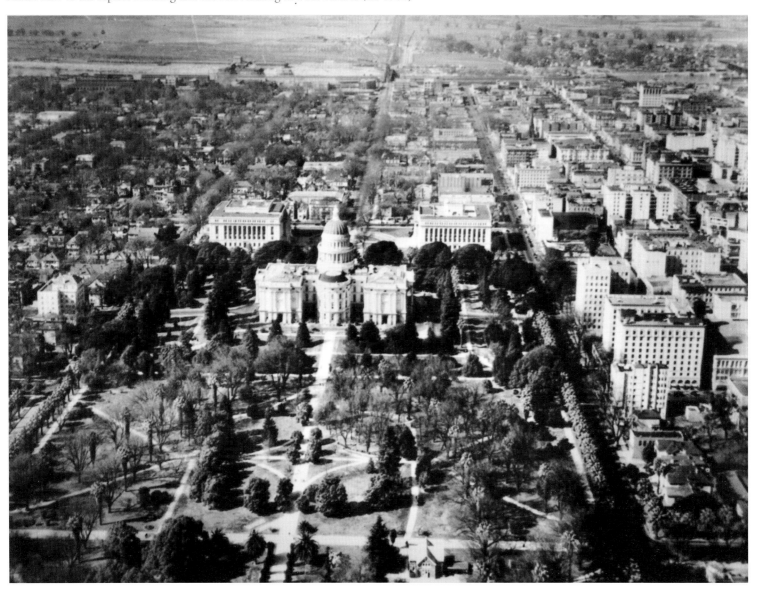

A view of J and Front streets (ca. 1931). Businesses include Square Deal Clothing Store, Western Labor Agency, and the Wheel Hotel.

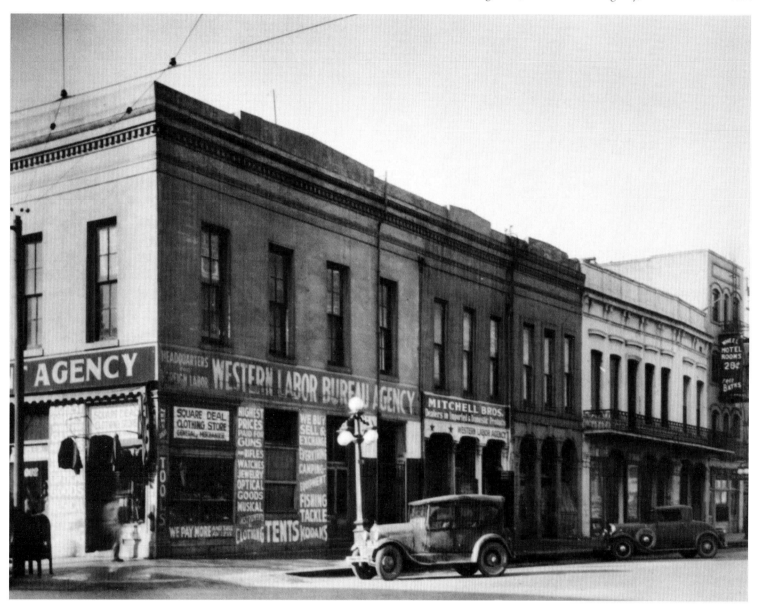

Downtown Sacramento (ca. 1938)

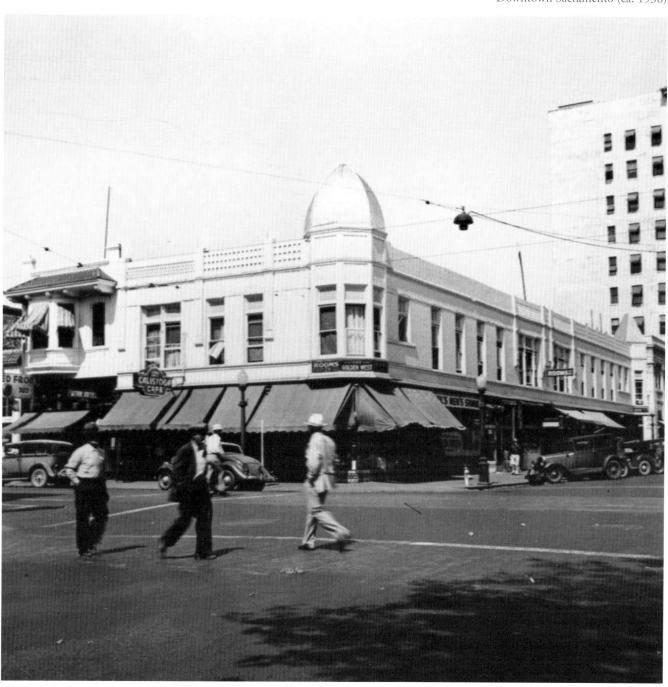

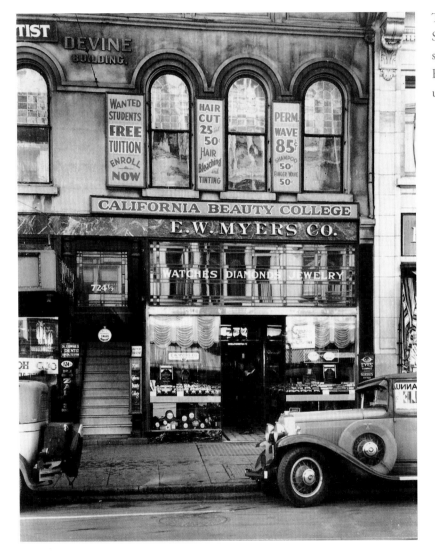

The E.W. Myers Jewelry Store on K Street, with signs for the California Beauty College located upstairs (ca. 1931)

Capitol Theater at K Street (ca. 1937)

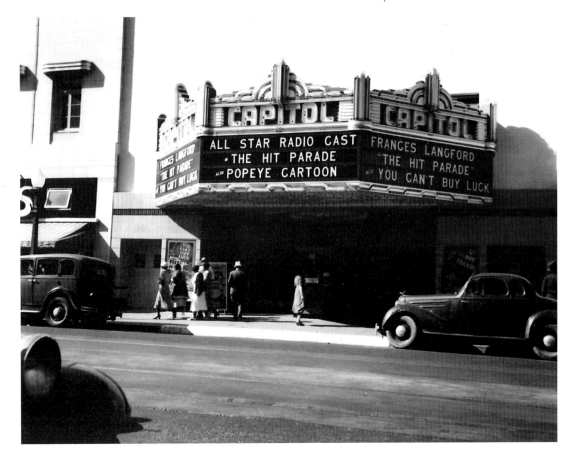

View of K Street (ca. 1920). Hotel Land and Hotel Sacramento are visible to the right.

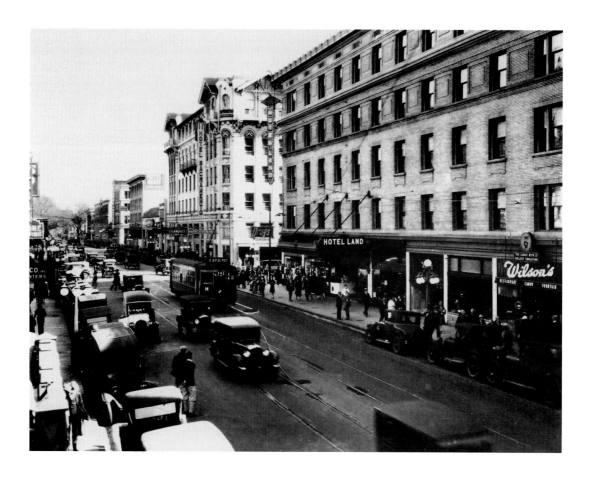

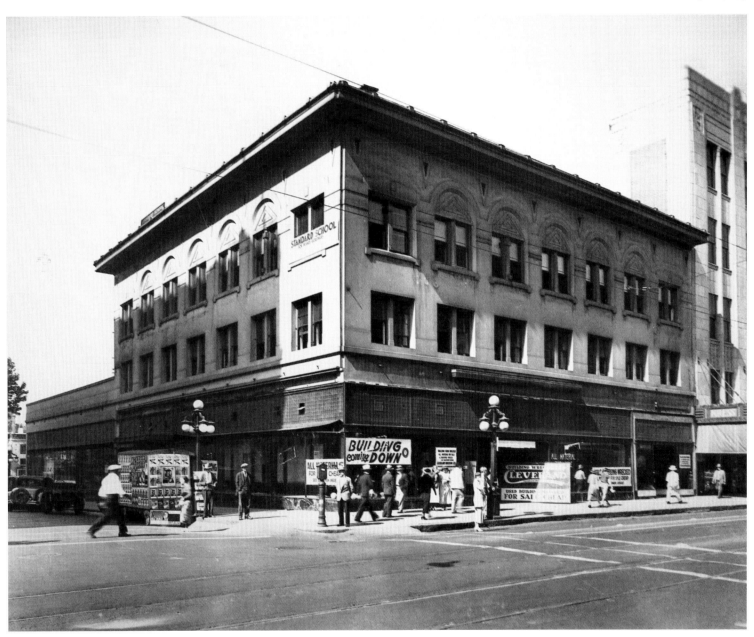

The Mebius and Drescher Co. Wholesale Grocers building, at the
southeast corner of Front and K streets (ca. 1931)

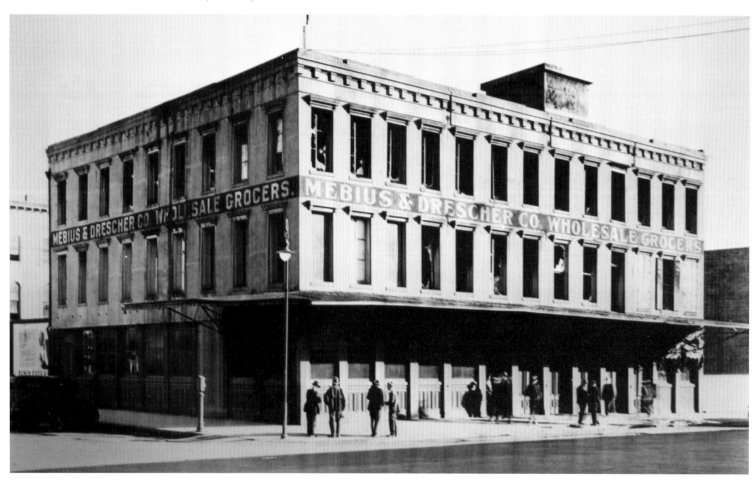

A view of K Street (ca. 1938). The Flying Eagle Cafe, Capitol Loan, Rialto Theater, and the Equipoise Cigar Shop are visible.

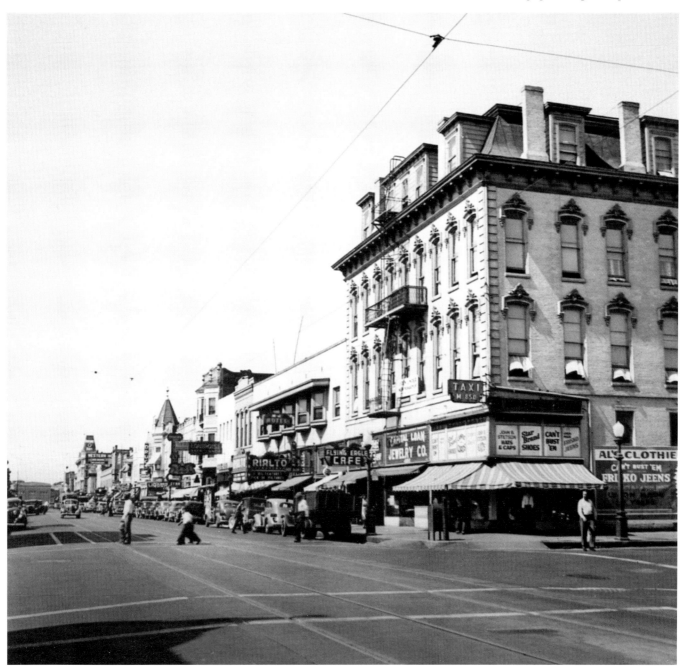

Western Hotel and other businesses at K Street (ca. 1937)

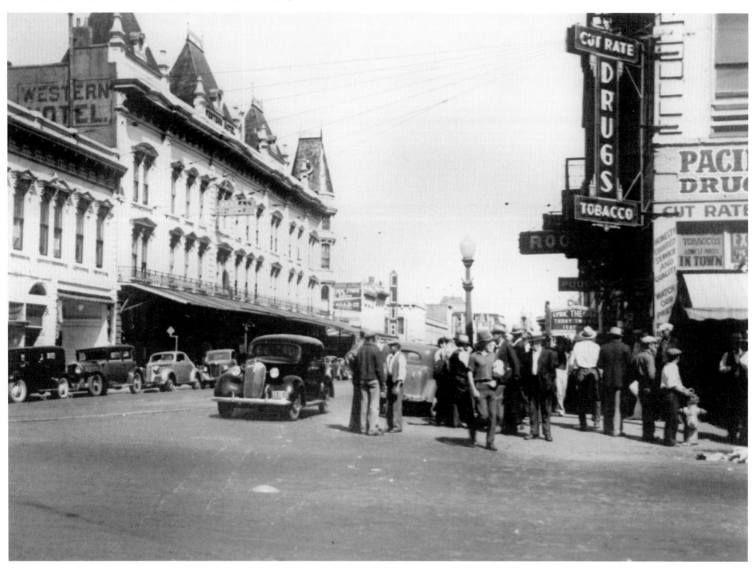

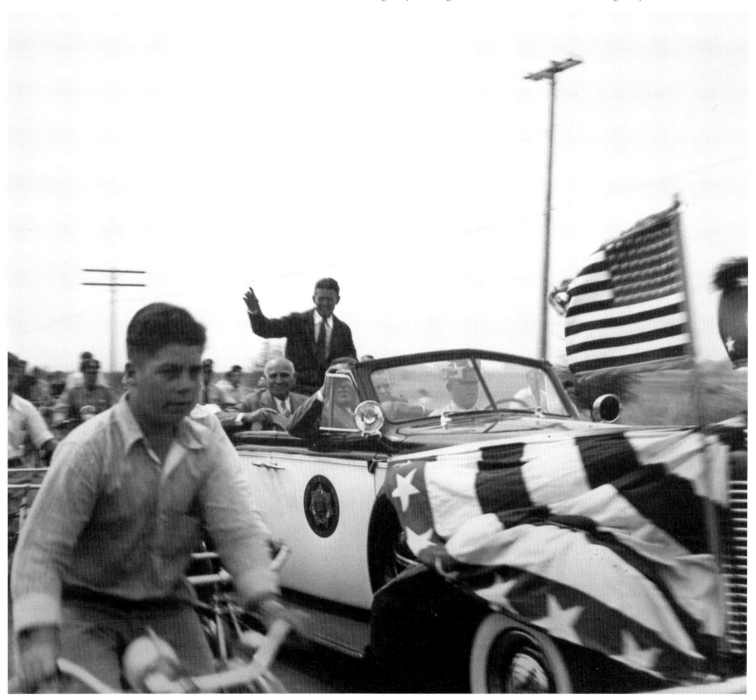

"Wrong Way" Corrigan in a convertible California Highway Patrol car (ca. 1938)

K Street (ca. 1931). Hotel Land, the Sutter Restaurant, Hotel Sacramento, and the Hippodrome are visible.

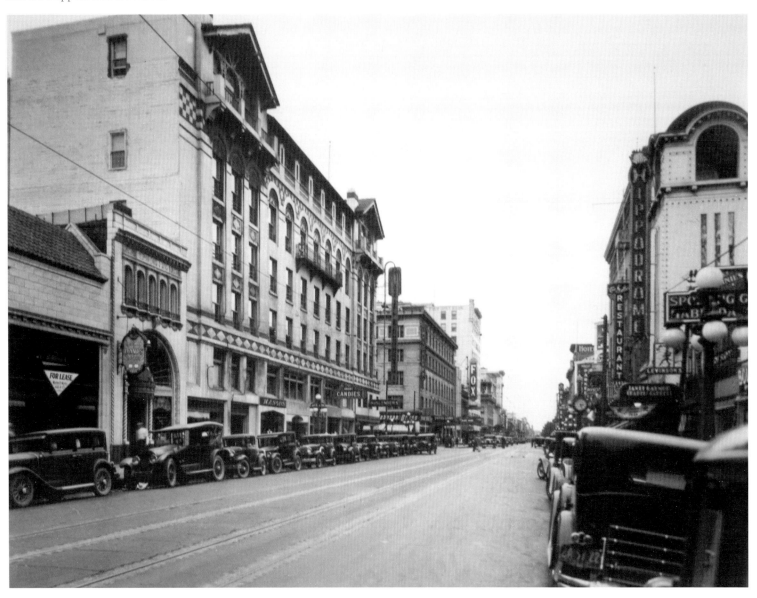

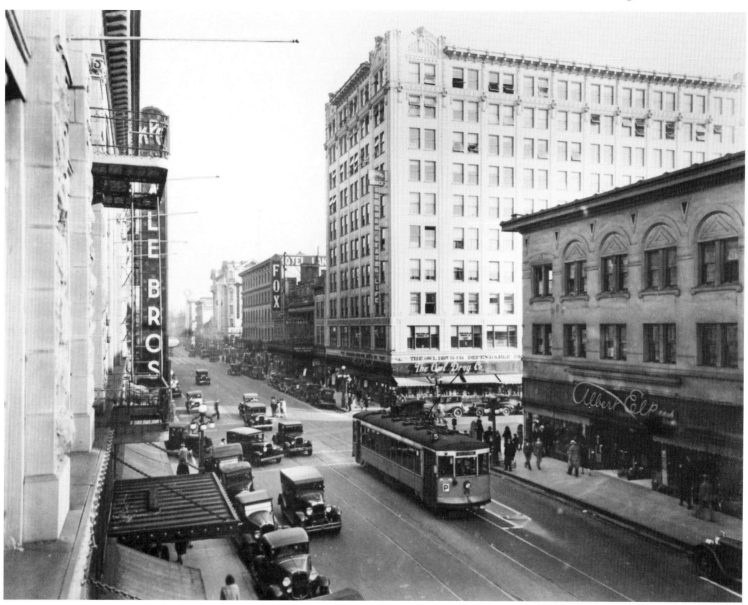

View of K Street (ca. 1931). Visible businesses include Hale Bros., the Owl Drug Co., and Albert Elkus.

View of Firehouse #4 at 5th Street (ca. 1938). Lun's Laundry is next door and Capitol City Plating Works behind.

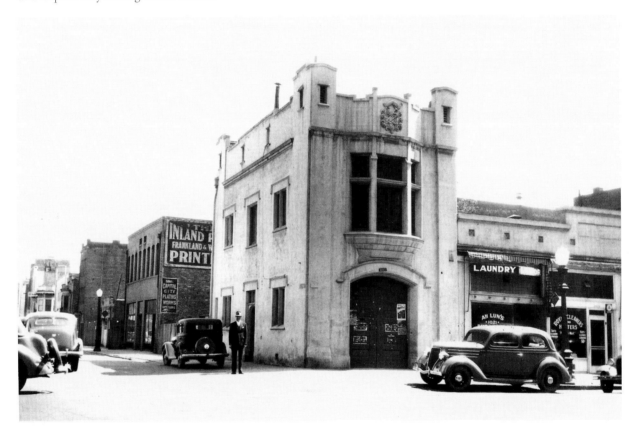

Pony Express historic marker (ca. 1938)

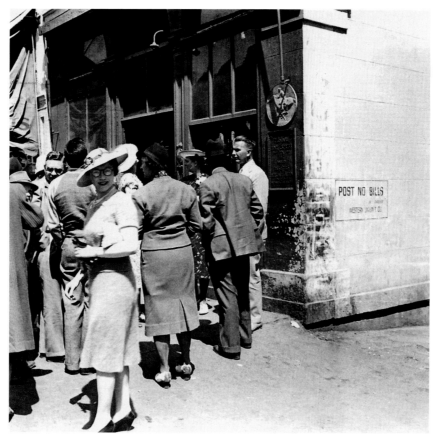

Streetcar at 7th and K streets with Post Office in the background (ca. 1930)

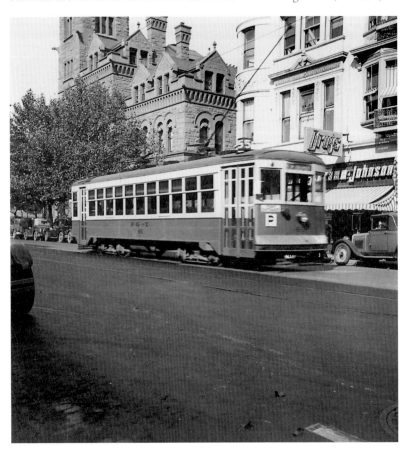

Front gate of Sutter's Fort
at L Street (ca. 1939)

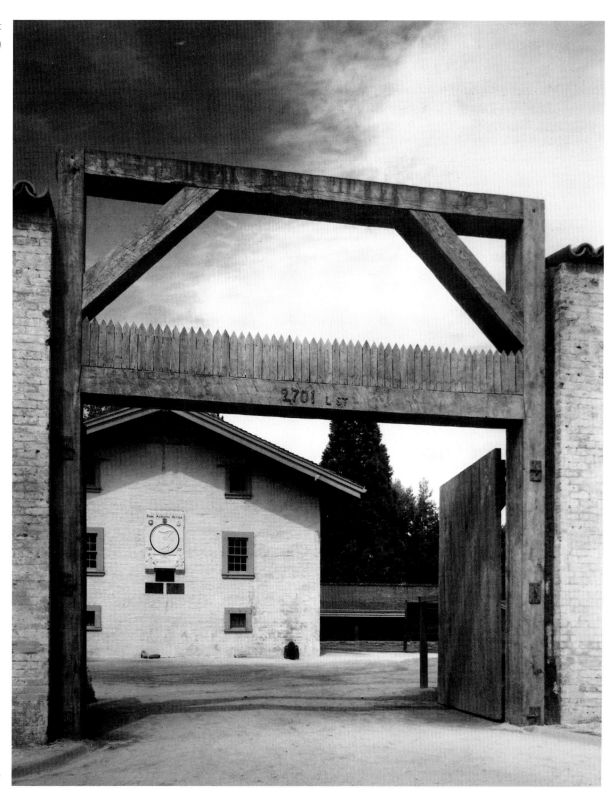

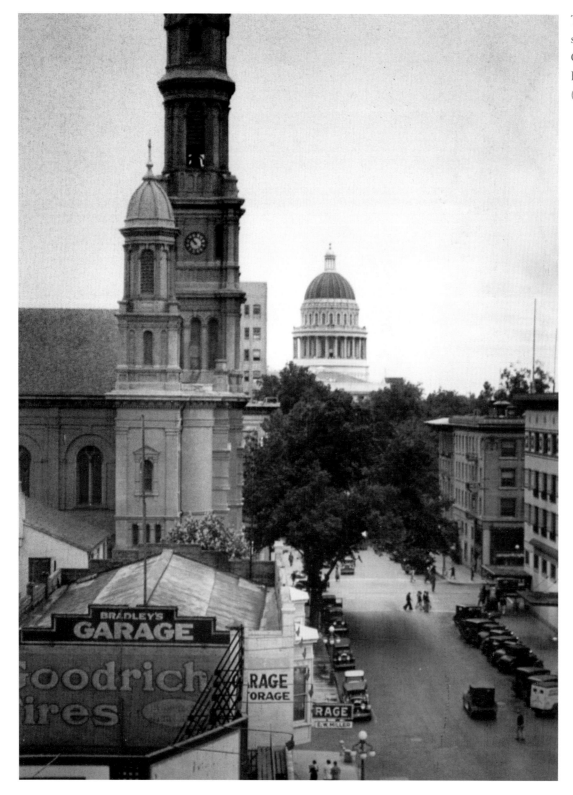

The California
state capitol and
Cathedral of the
Blessed Sacrament
(ca. 1932)

View of K Street (late 1930s)

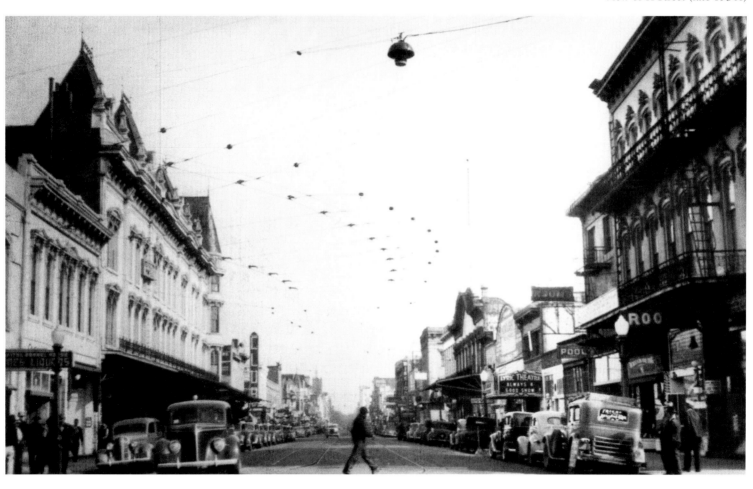

Downtown Sacramento at 10th and J streets, where the U.S. Navy *Akron*
floats high over the California Life Insurance Building (ca. 1932)

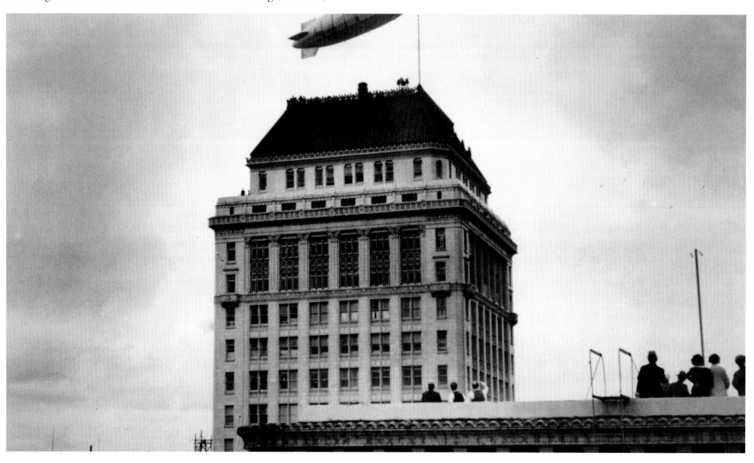

View of K and 10th streets

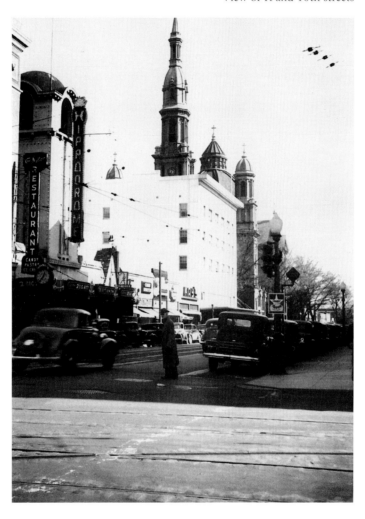

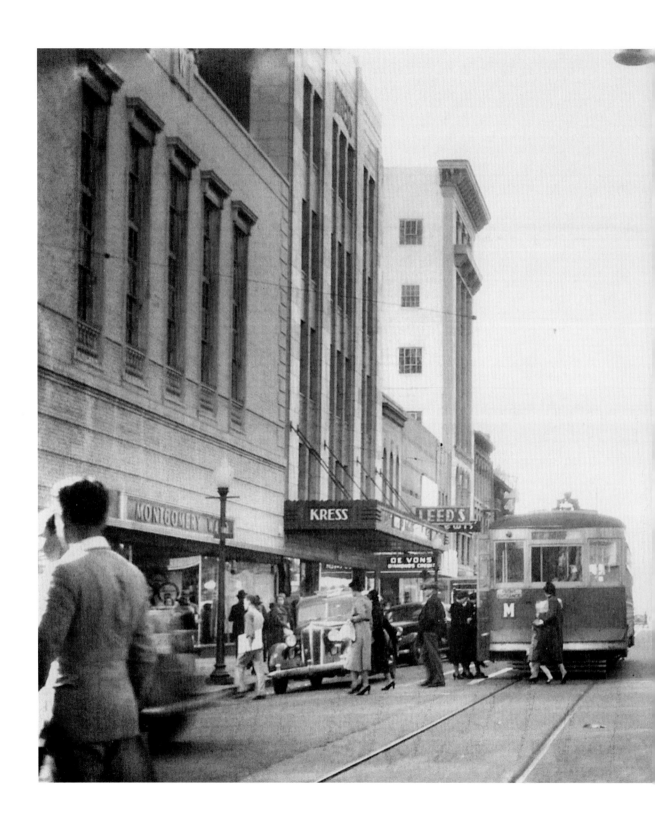

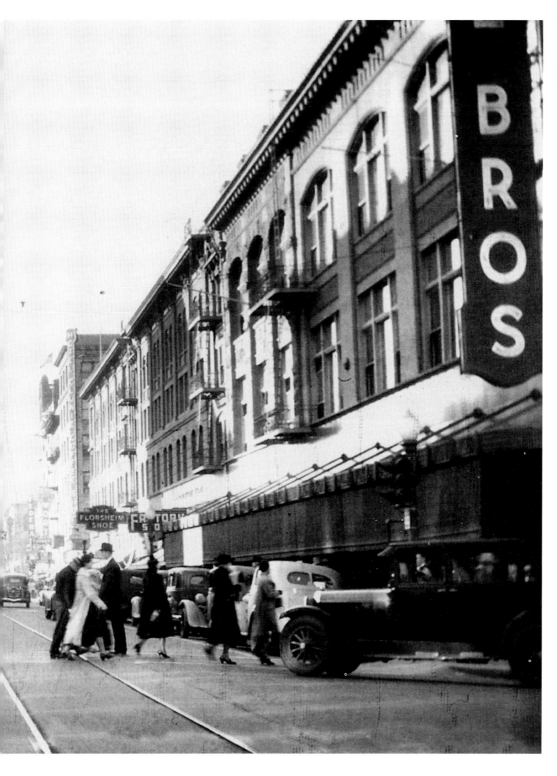

The S. H. Kress and Co. and Montgomery Ward stores are visible among other businesses in this view of K Street. (late 1930s)

A view of 10th and L streets. Mission Orange Coffee Shop and Red Heart Pastry
Shop are visible at the corner, Hotel Land in the distance.

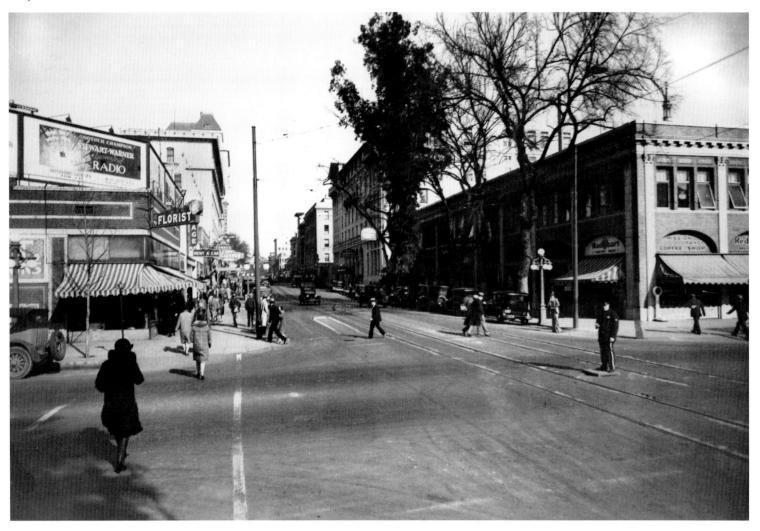

A City Facing the Future

1940–1969

Sacramento's younger citizens, fresh out of school and ready to take on the world, got their chance in 1942, when they found themselves in uniform to fight abroad, or aid efforts on the home front. By 1946, returning warriors filled colleges and revitalized the workforce. The aircraft industry created a new boom in housing and employment and the city's population expanded by 63 percent between 1940 and 1950.

Suburban shopping centers and housing developments pulled investors away from an aging downtown, starting its slide into disrepair and despair. Sacramento also lost a part of its heart in 1947 when its beloved baseball stadium, Edmonds Field, burned. Politics continued to play an important part in the daily round of the state capital, and the capital grounds and the city's cathedral kept visitors awed. An efficient system of streetcars was dismantled to encourage the use of automobiles, while freeways began to span the county.

Although the advent of television and the public's changing tastes soon affected downtown theaters, movies were still money-makers. Six drive-in theaters and more than two dozen screens were active. Fires, rain, and even snow visited the capital region, while rampaging floods devastated northern California and threatened the county's levees once again.

The blighted "West End," once the heart of Sacramento, had become a skid row and the highest source of crime and disease in the city by the mid 1950s. In the early 1960s, the hot political issue of redevelopment would forever change the riverfront district. The 28 acres of buildings still standing after renovation became "Old Sacramento," a registered historic landmark that once again offered food, drink, and merchandise to the tourists and locals walking the cobblestone alleys that dipped down to the original, pre-1863 street level.

As the turbulent decade ended, change was evident on many fronts. Terms like "strip mall" and "Cineplex" started to waft throughout once-rural communities. "K" Street's transformation from a bustling thoroughfare to a monolith-strewn curiosity and a concrete Cal Expo, in place of the Old Fairgrounds, confused longtime residents as Sacramento again braced itself for a future no one could accurately predict.

The *Spirit of St. Louis* is on display during a visit by Charles Lindbergh to Mather Field.

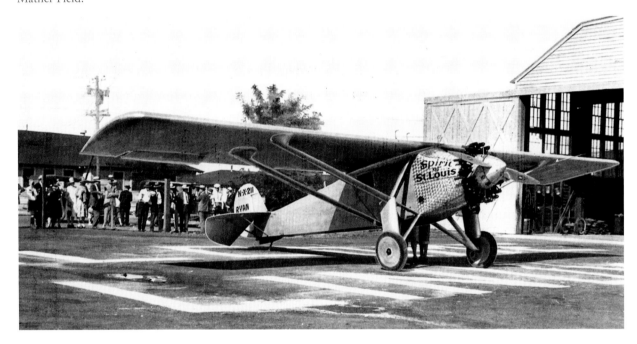

A view of 4th and M streets (ca. 1942)

Alhambra Theatre at 31st Street and Alhambra Blvd. (ca. 1940)

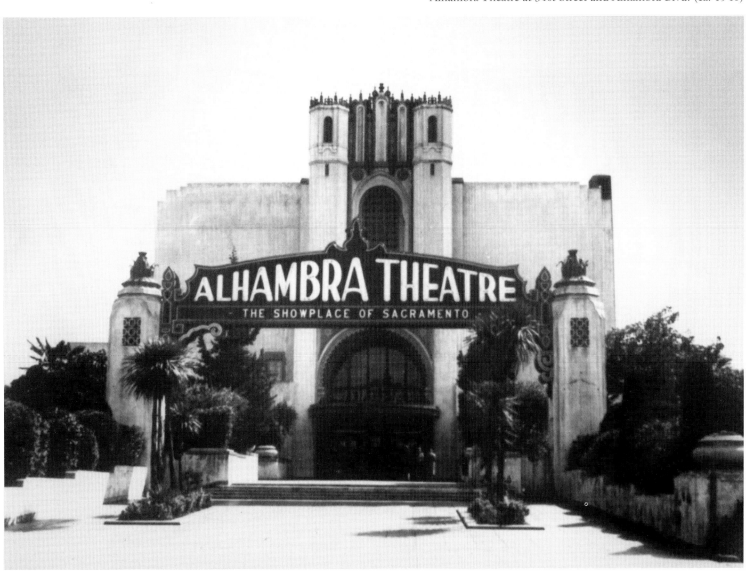

Moviegoers on K Street hasten inside to see Shirley Temple and other stars of the day. (ca. 1940)

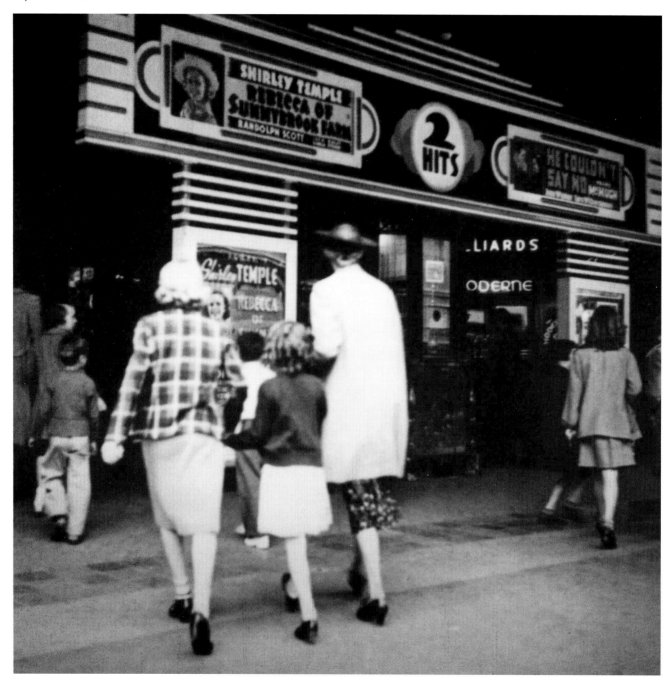

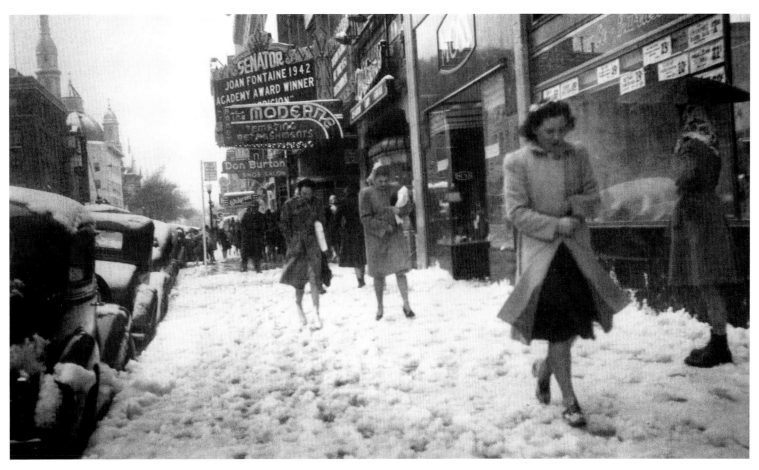

Western Pacific Railroad tracks near
the depot on J Street (ca. 1940)

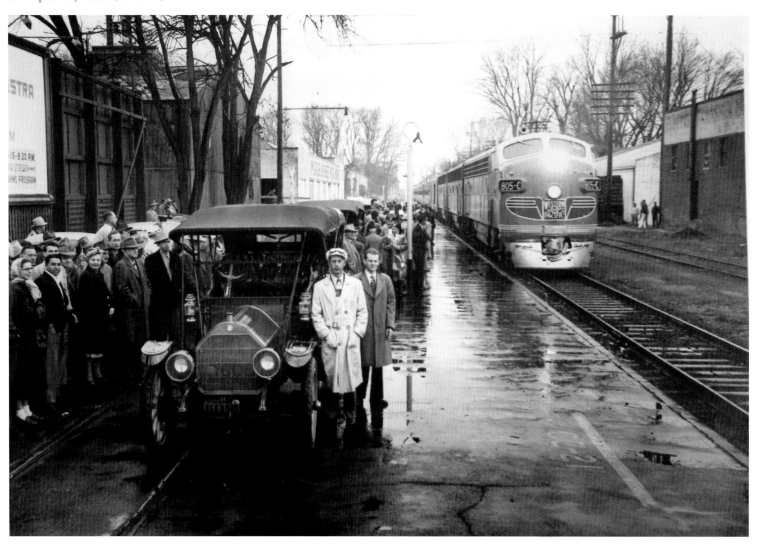

Fire at El Rey
Theater at J Street
(ca. 1941)

Firemen struggle to contain the El Rey Theater blaze.

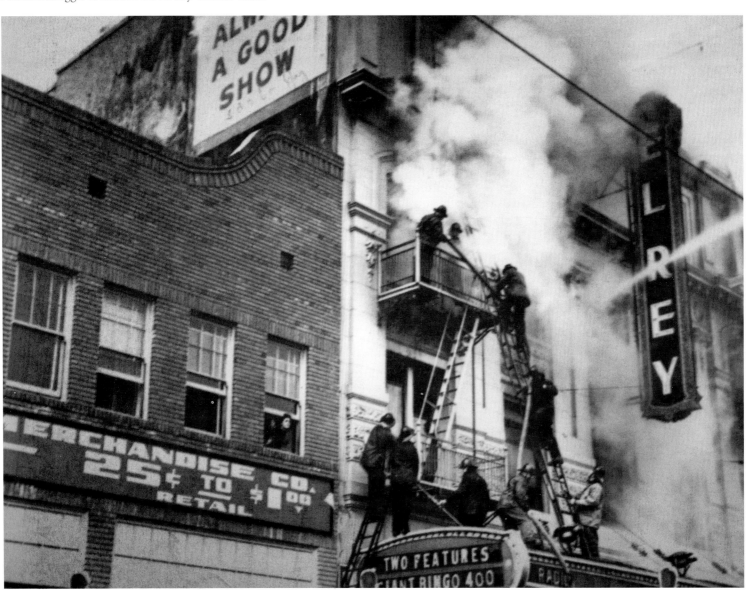

Removal of streetcar tracks at 10th and K streets (ca. 1948)

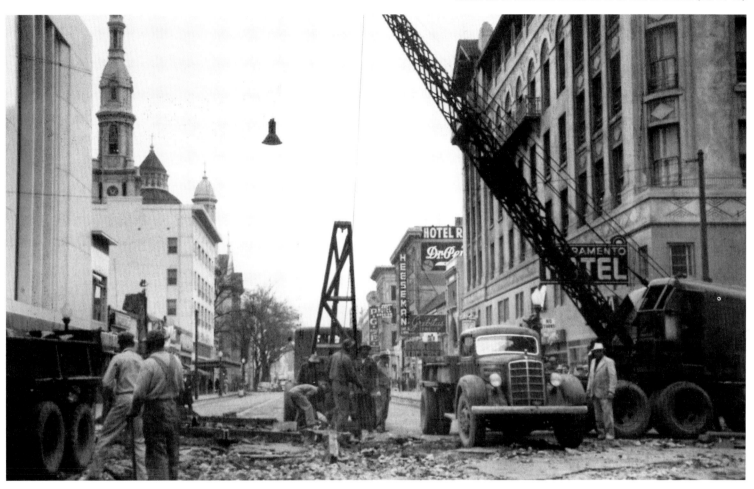

Demolished tracks at 10th and K streets (ca. 1948)

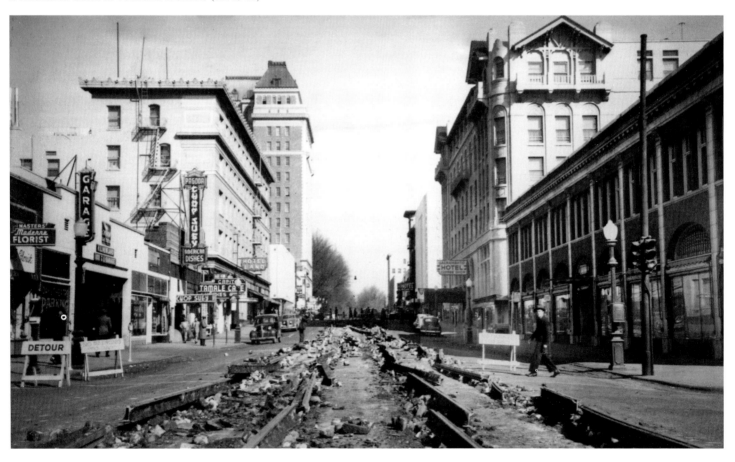

Admission Day parade at K Street (ca. 1940)

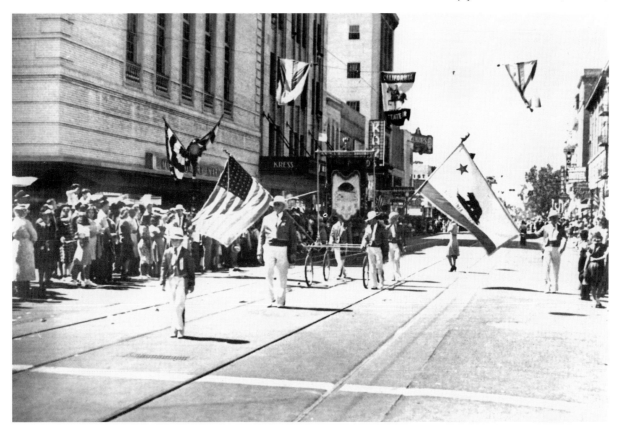

Mercy Hospital at J Street (ca. 1942)

View of 3rd and K streets

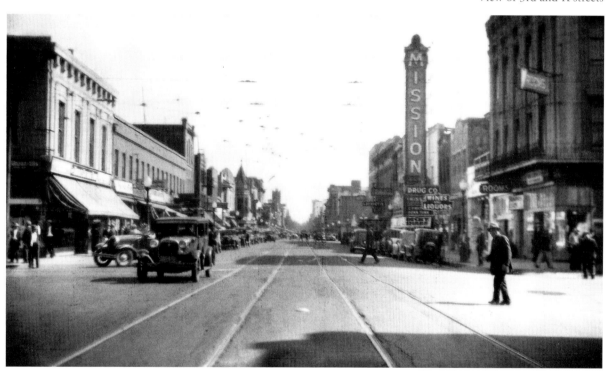

View of 9th and K streets (ca. 1945)

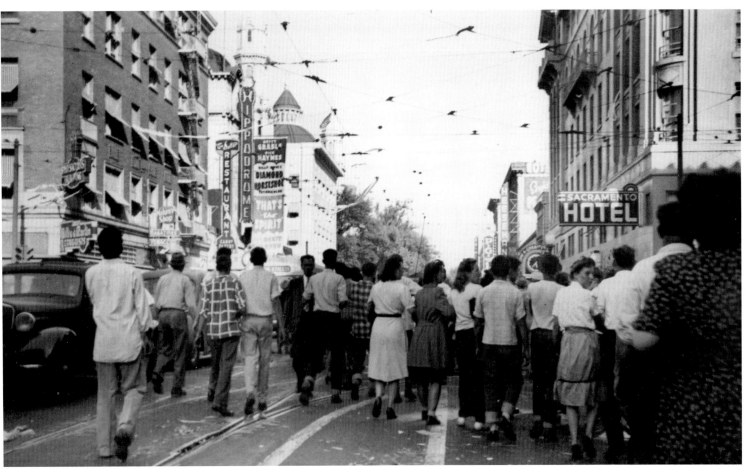

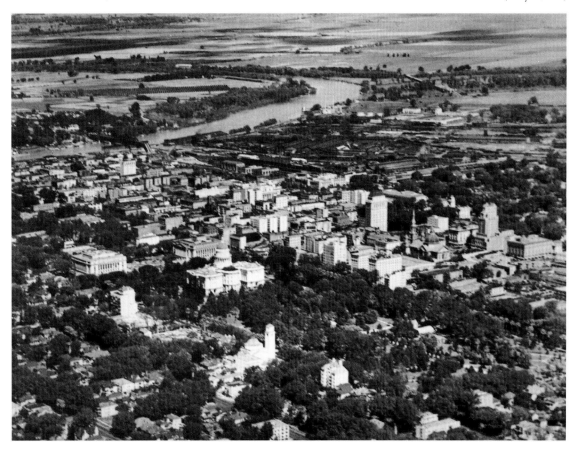

An aerial view of Sacramento downtown (early 1940s)

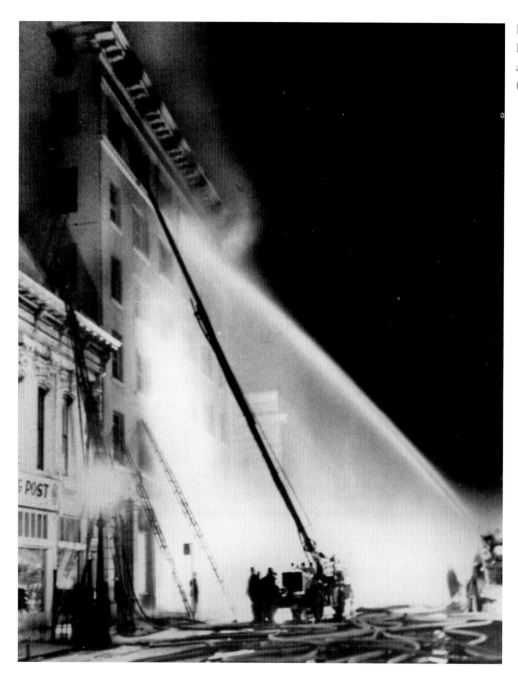

Fire at the Bryte
Building at 7th
and J streets
(ca. 1940)

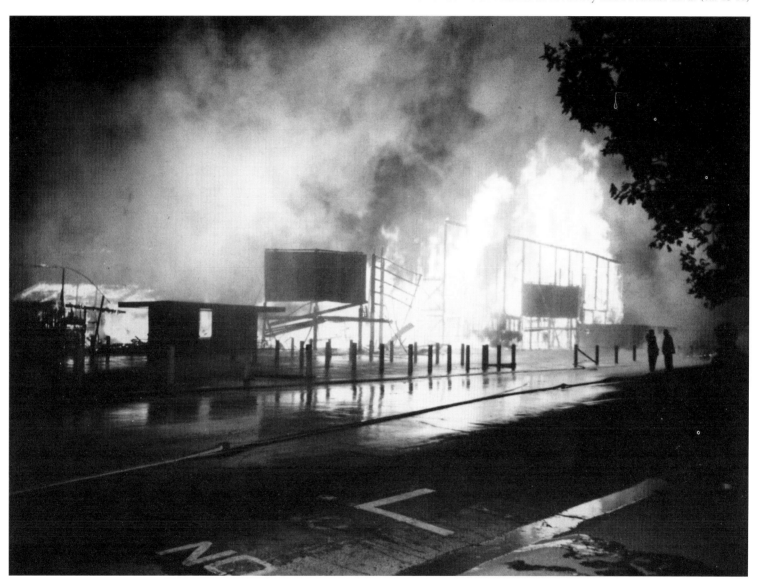

View of 4th and M streets (ca. 1942)

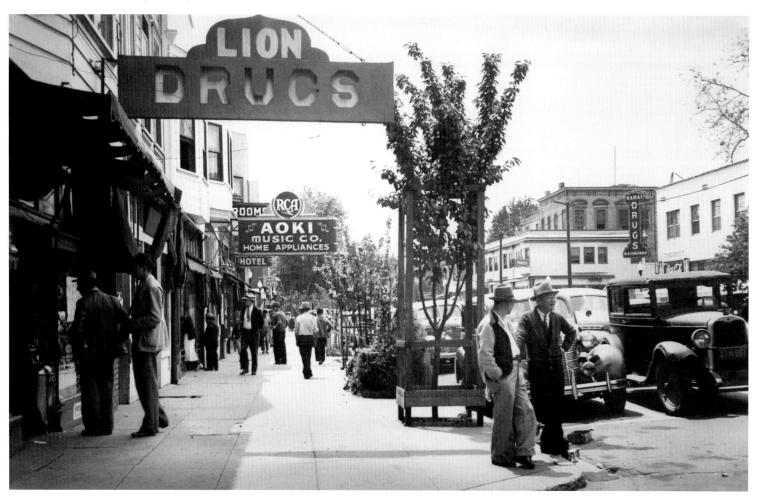

View of 4th and M streets (ca. 1942)

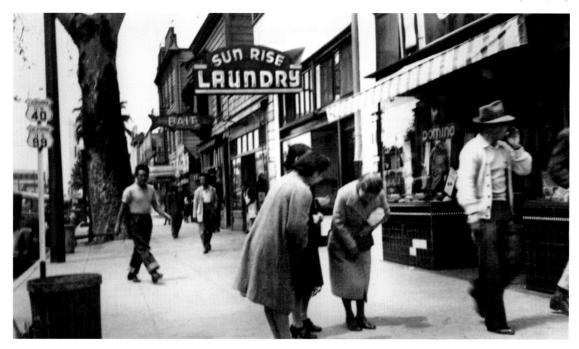

View of 9th and K streets (ca. 1942)

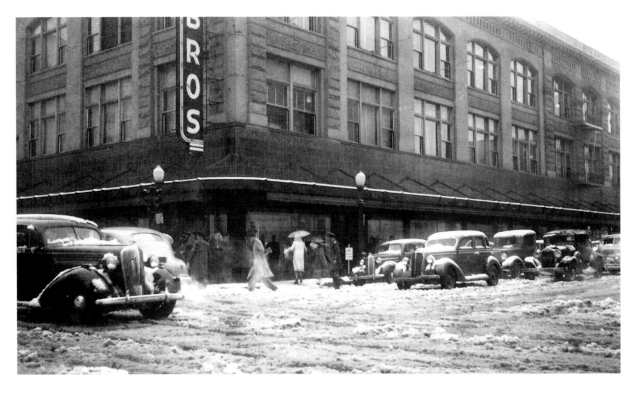

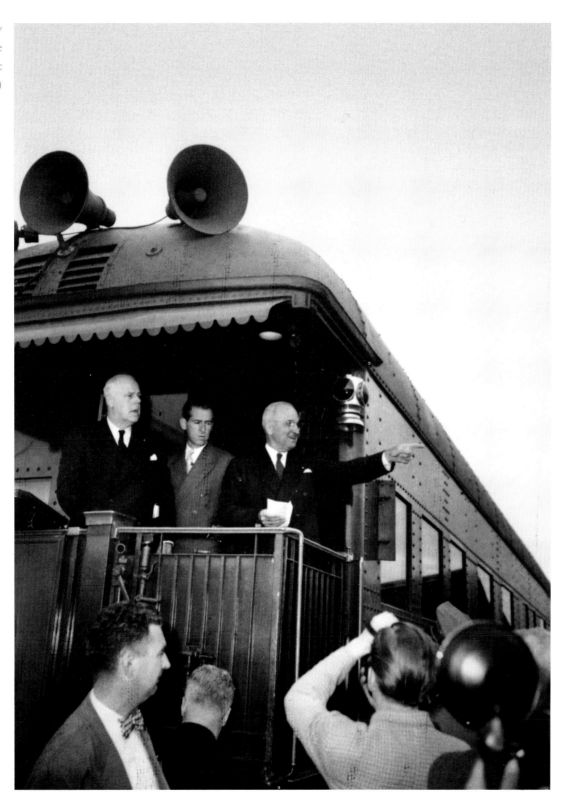

President Harry Truman at the Southern Pacific Depot (ca. 1948)

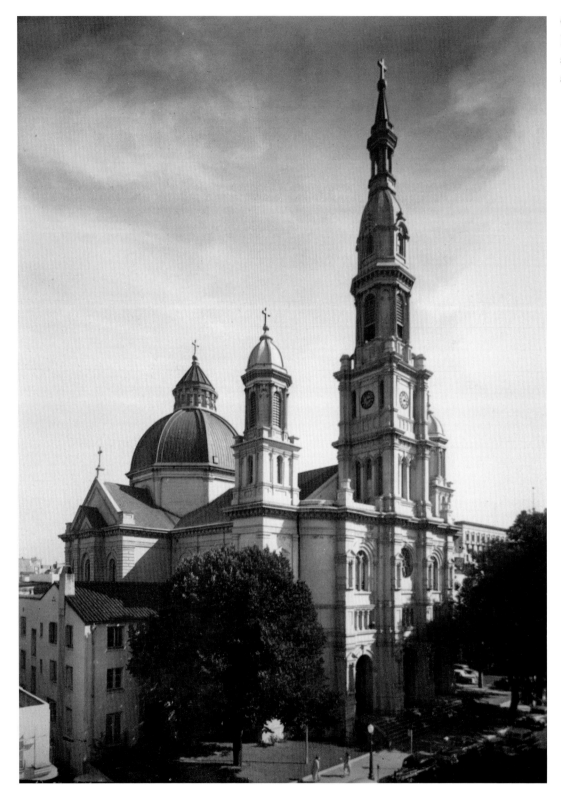

Cathedral of the
Blessed Sacrament
at 11th and K
streets (ca. 1949)

As capital of the "Golden State," Sacramento is home to the magnificent State Capitol. (ca. 1960)

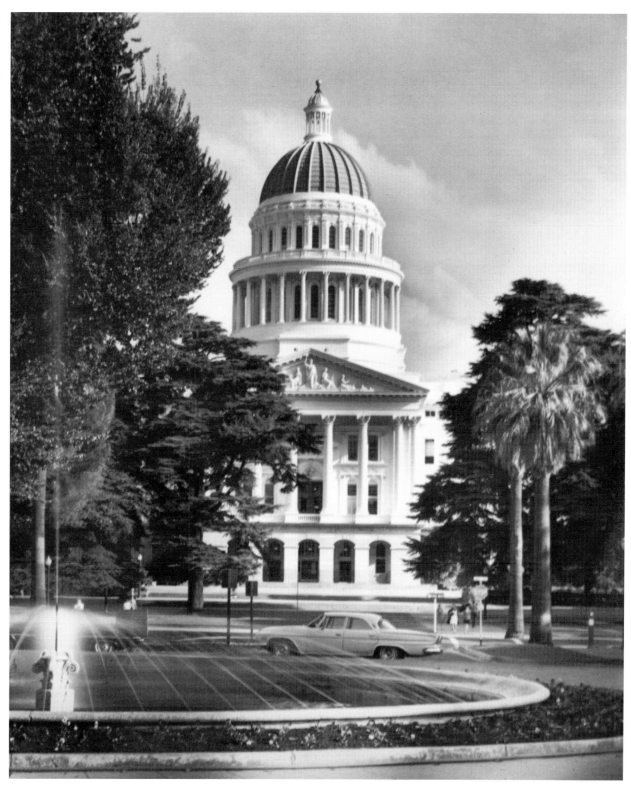

The Agricultural Building (later called the Treasurer's Building) at the
capitol mall (ca. 1950)

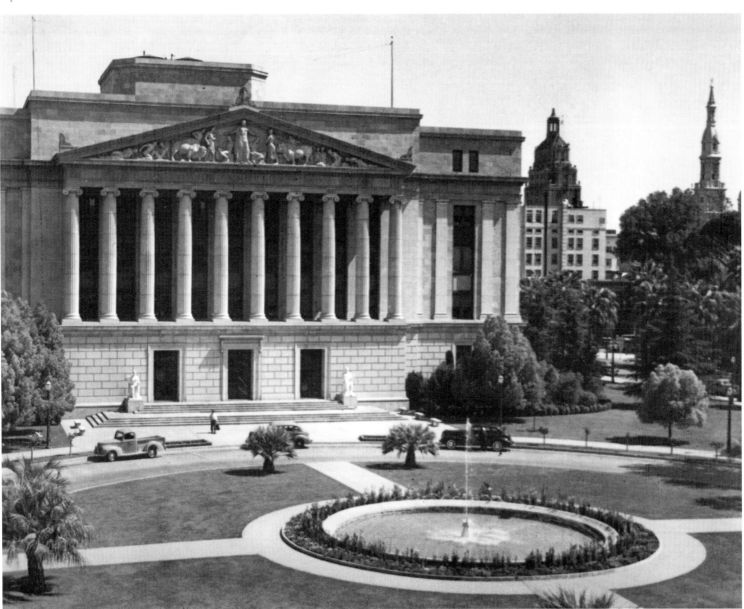

Sacramento Municipal Airport under construction at Freeport Blvd. (ca. 1954)

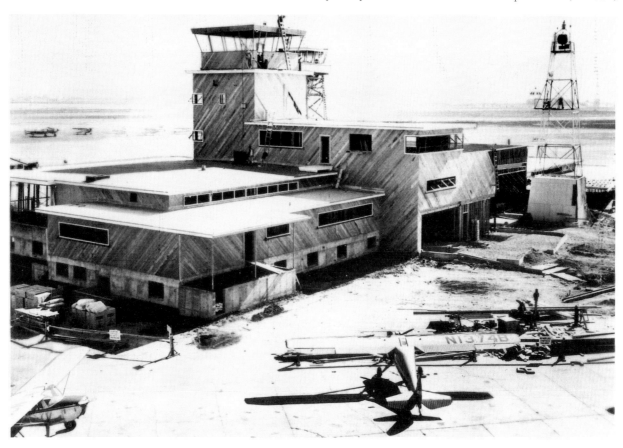

Southern Pacific Depot (ca. 1955)

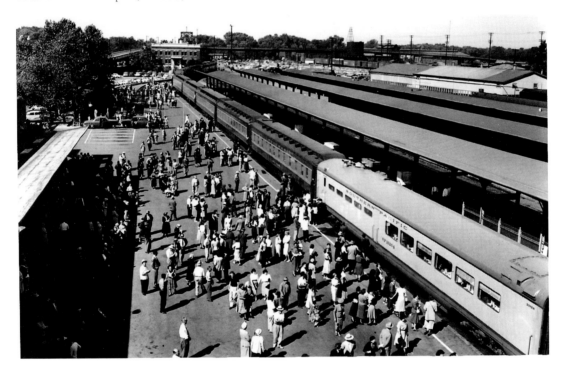

A political campaign parade with Governor Adlai Stevenson in an open car at K Street (ca. 1955). Weinstock Department Store and Sears Roebuck and Co. are visible in the background.

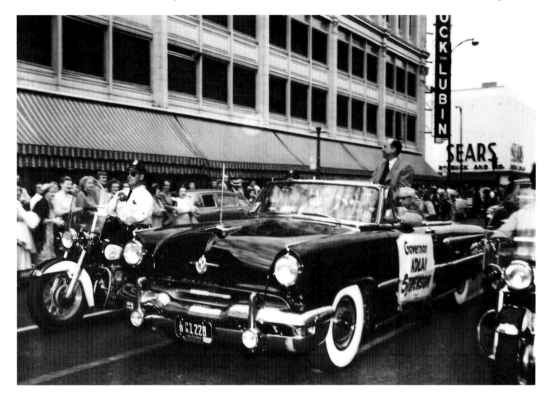

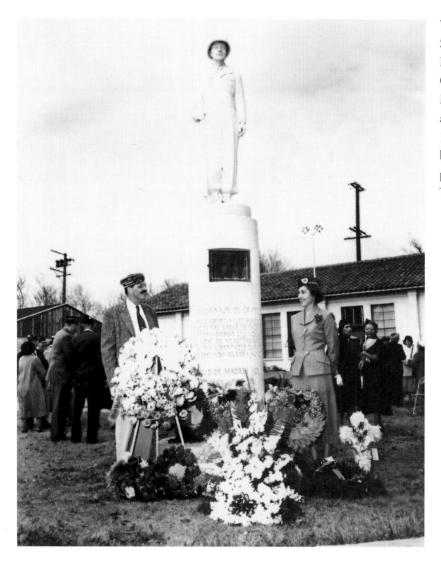

Veterans Memorial Service by the Madres de la Guerra at the Mexican Center at 6th Street (ca. 1954). In the background is a partial view of the Tony Beretta Club.

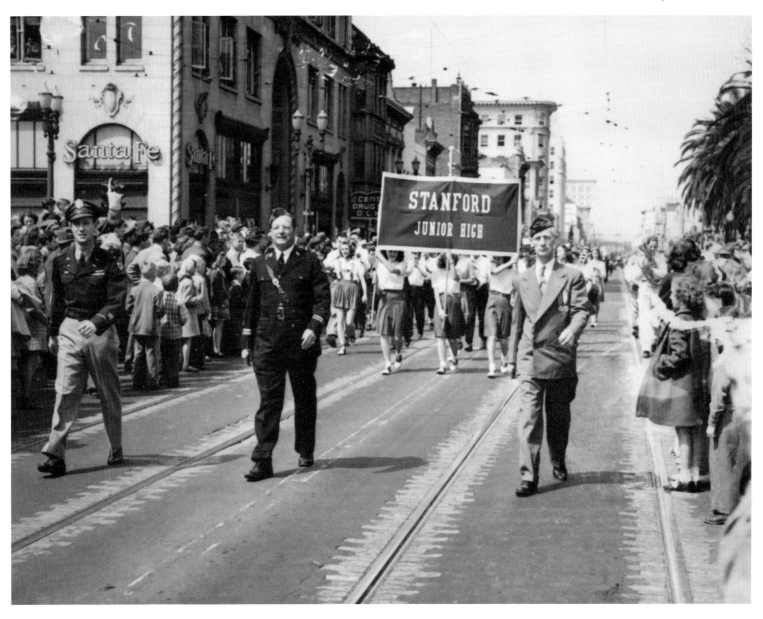

Entrance to Capitol Park at 10th and L streets (ca. 1952)

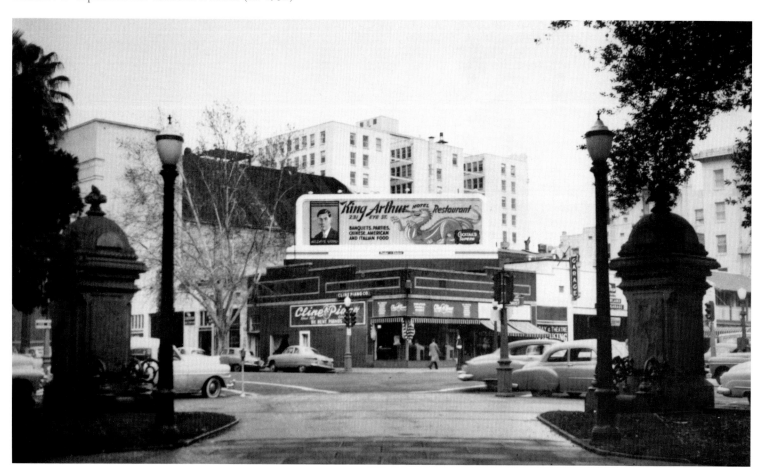

At 2nd and K streets

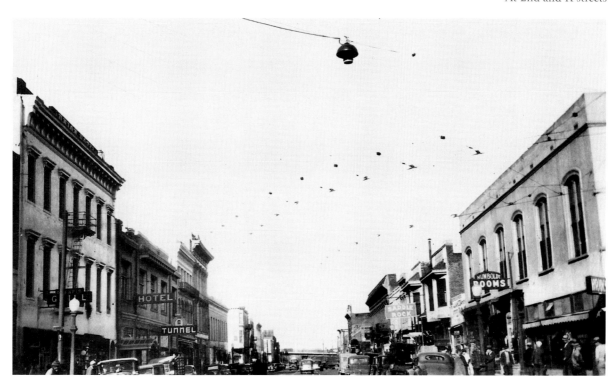

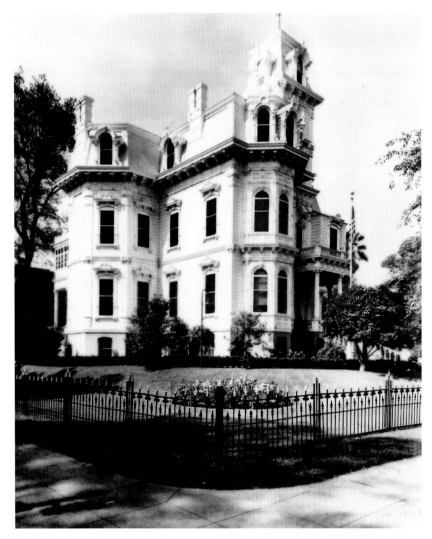

The governor's mansion (originally the Albert Gallatin House) at 16th and H streets

A crowd forms in front of Weinstock's Department Store.

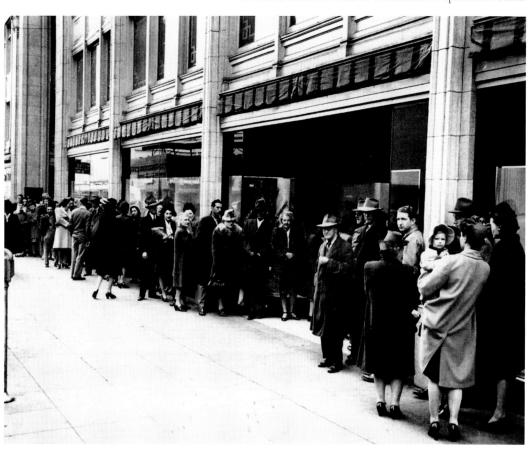

Scottish Rite Temple at L Street (ca. 1950)

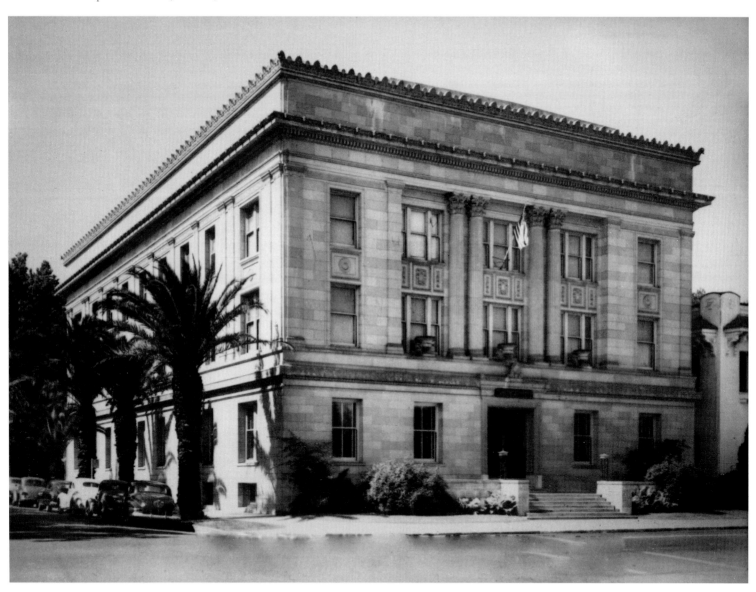

Sacramento firemen demonstrate the ladder rescue. (ca. 1950)

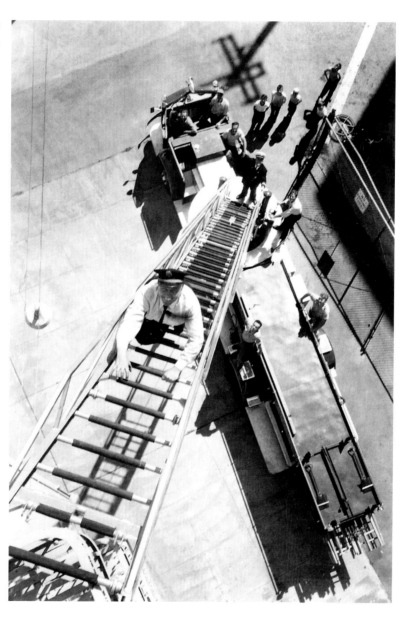

A fire engine in front of the Fox Senator Theater (ca. 1952)

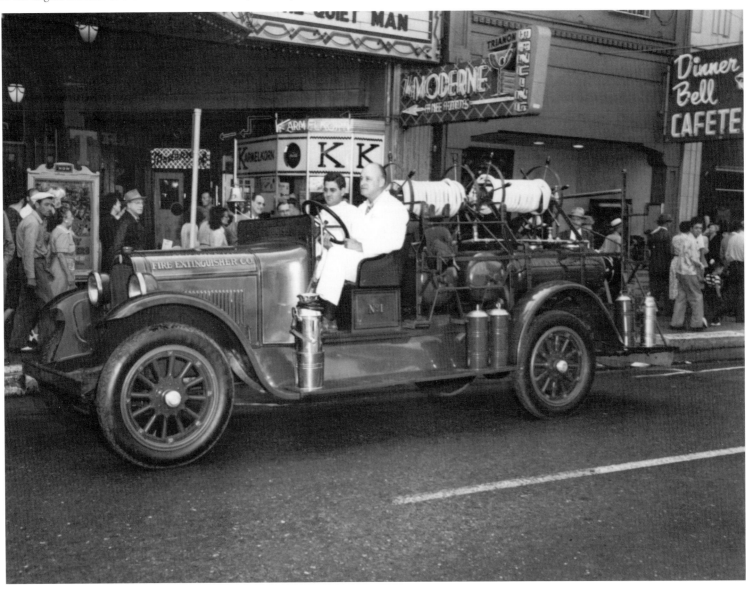

California State Capitol Park at L Street (ca. 1950)

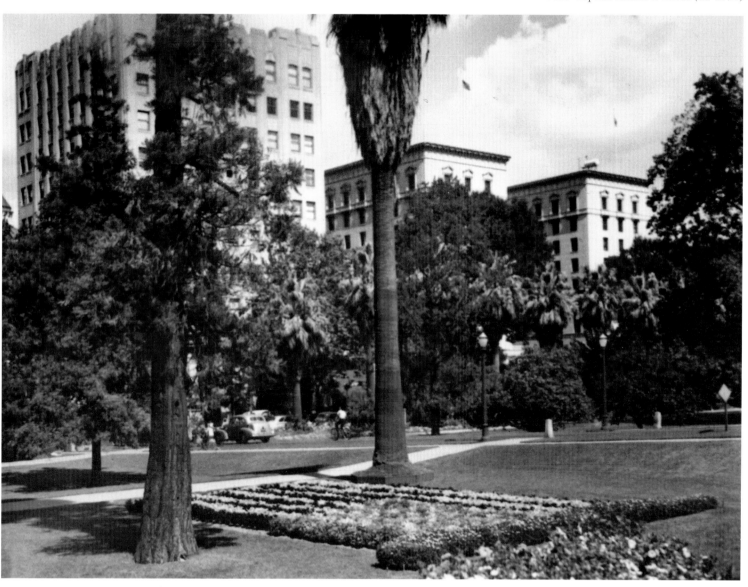

A parade at 10th and J streets (ca. 1950). The Atchison, Topeka, and Santa Fe Railroad office is visible.

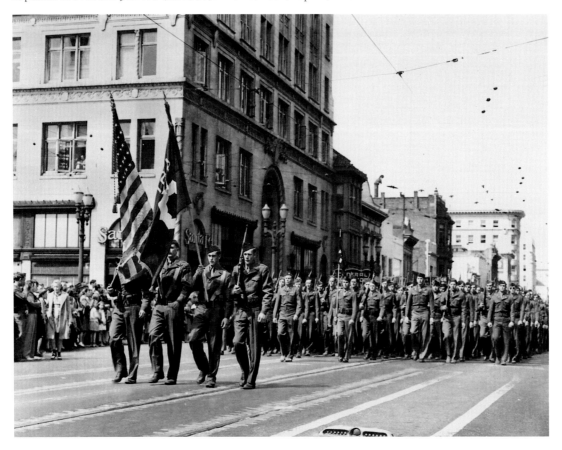

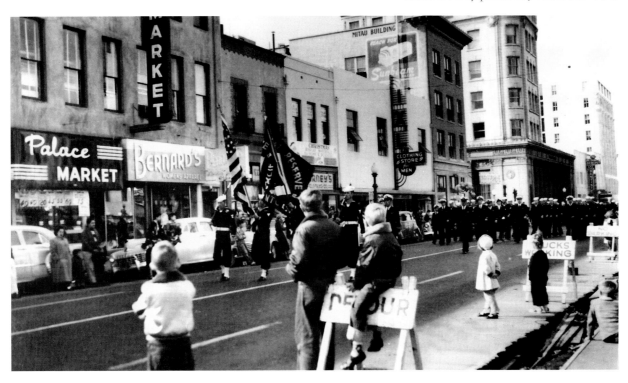

Armistice Day parade at J Street (ca. 1951)

A tank at the Armistice Day parade rolls past. (ca. 1951)

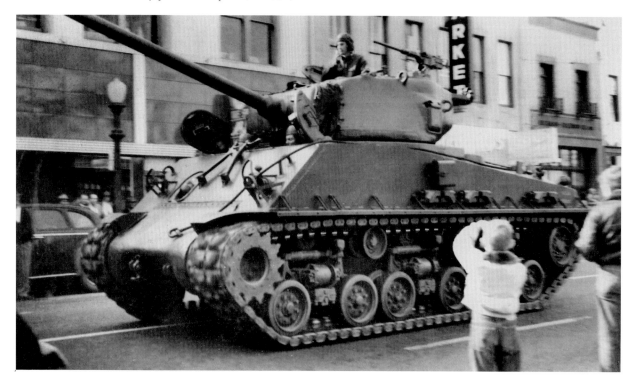

Armistice Day parade at J Street (ca. 1951)

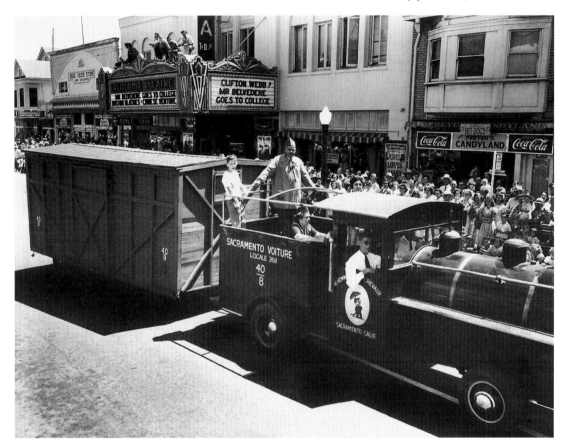

The California state fair, at Stockton Blvd. (ca. 1954)

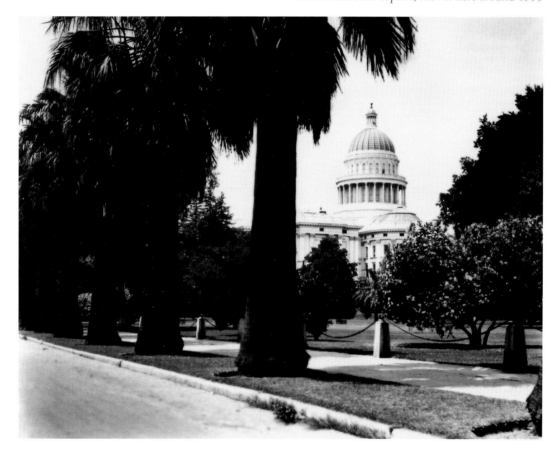

California's state capitol, shown here around 1955

Stan's Drive-In Restaurant at Freeport Blvd. (ca. 1952)

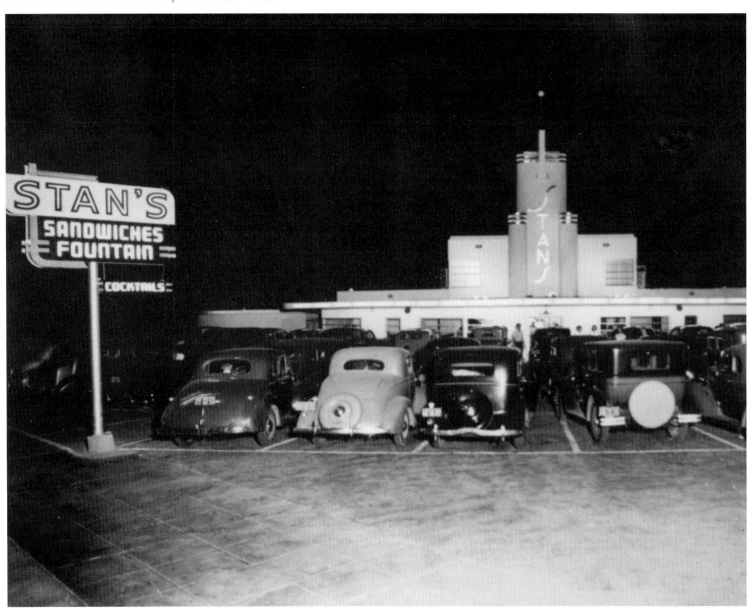

El Rancho Hotel in west Sacramento (ca. 1959)

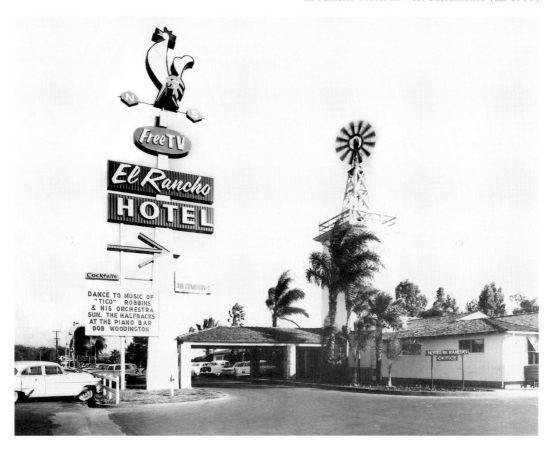

Tower Bridge

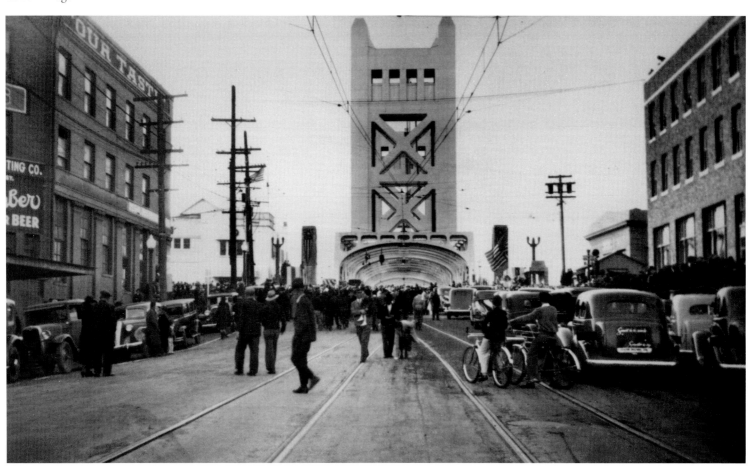

A notice posted on a Sacramento corner during World War II. While approximately 10,000 Japanese and Japanese Americans were able to relocate to other parts of the country, roughly 110,000 men, women, and children were sent to camps called "War Relocation Centers" in remote central areas of the nation.

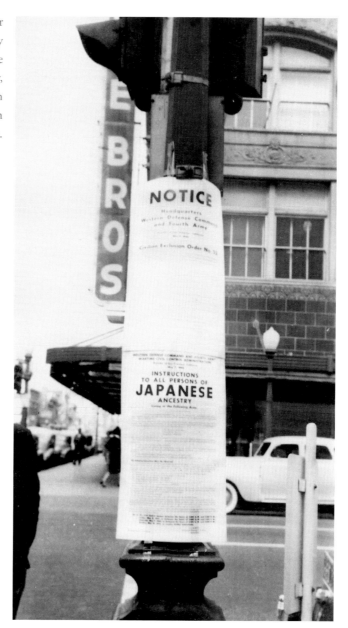

Weinstock's Department Store at 12th and K streets (ca. 1960)

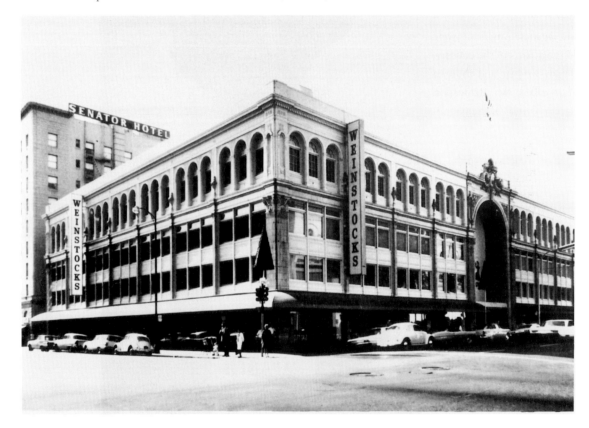

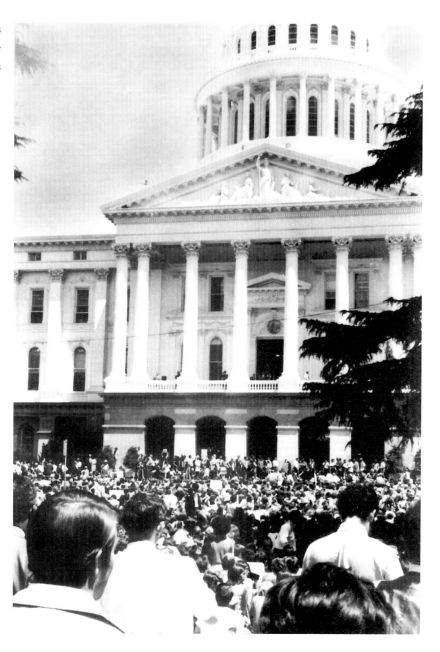

A rally in progress
on the state
capitol grounds
(ca. 1969)

K Street (ca. 1948)

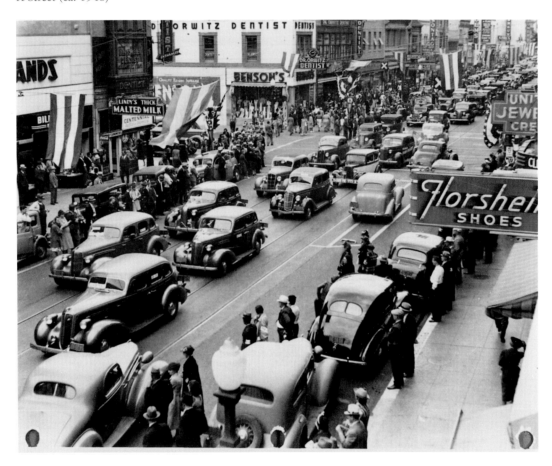

City Hall at I Street (ca. 1965)

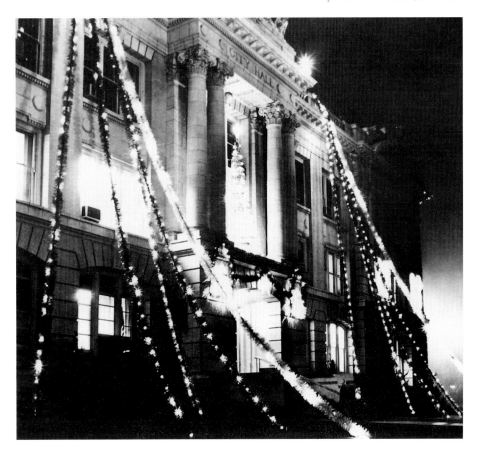

Flooded streets at 43rd Avenue and Franklin Boulevard (ca. 1963)

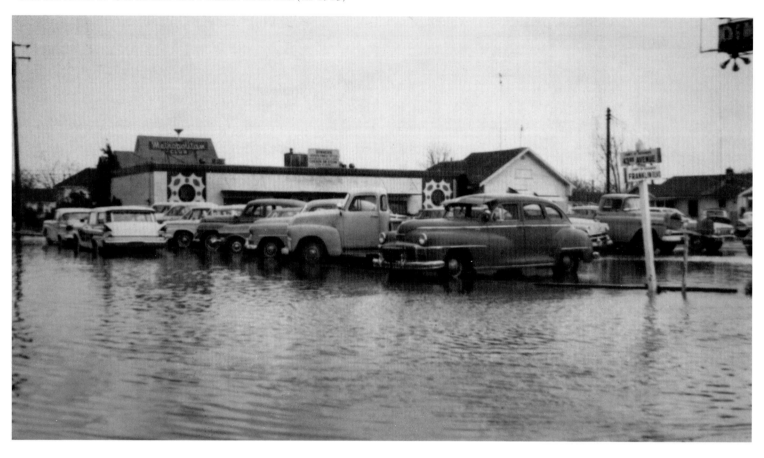

Governor Ronald Reagan, seated at right, looks on as Spiro Agnew speaks from the Capitol steps. (ca. 1969)

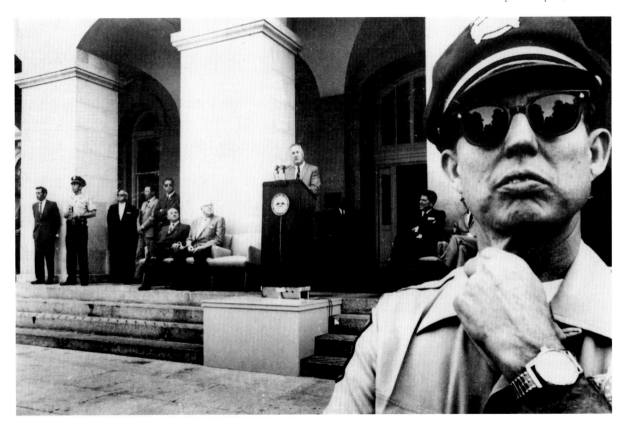

An aerial view of Sacramento as it looked around 1960

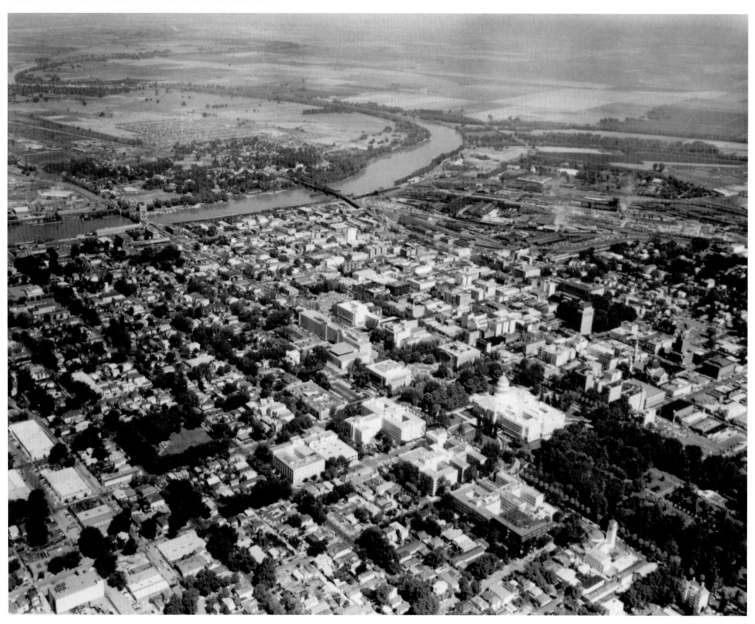

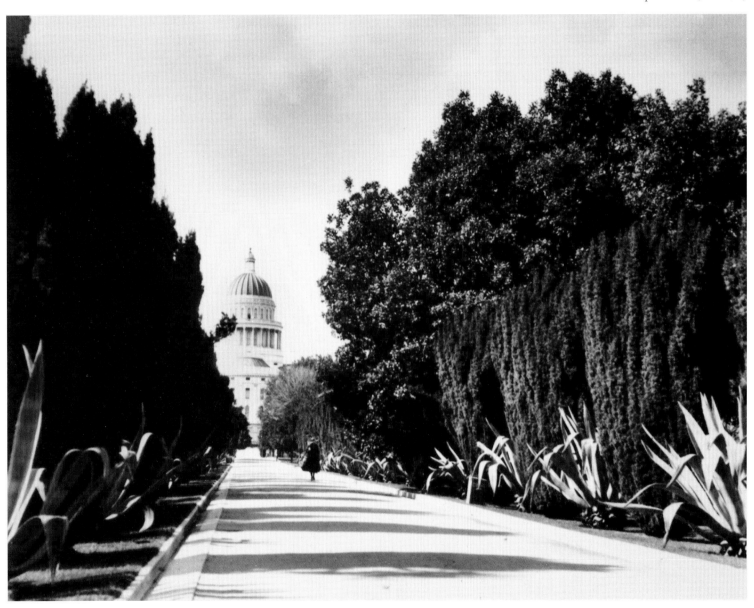

Notes on the Photographs

These notes, listed by page number, attempt to include all aspects known of the photographs. Each of the photographs is identified by the page number, photograph's title or description, photographer and collection, archive, and call or box number when applicable. Although every attempt was made to collect all available data, in some cases complete data was unavailable due to the age and condition of some of the photographs and records.

II Hippodrome
Sacramento Archives
1985/24/2096

VI Firefighters
Sacramento Archives
1973/03/08

X Central Pacific Depot
Sacramento Archives
1960/02/03

2 Central Pacific Depot
Sacramento Archives
1985/24/4230

3 Post Office
Sacramento Archives
1970/01/405

4 Cathedral of the Blessed Sacrament
Sacramento Archives
1997/32/07

5 State Capitol
Sacramento Archives
1985/24/4429

6 Kellog Hardware
Sacramento Archives
1985/24/3034

7 Wells Fargo
Sacramento Archives
1985/24/1964

8 Sacramento County Courthouse
Sacramento Archives
1970/01/148

10 Sacramento Wharf
Sacramento Archives
1989/41/4872

11 Front Street
Sacramento Archives
1985/24/1947

12 Eighth Street
Sacramento Archives
1985/24/2026

13 City Brewery
Sacramento Archives
1970/01/121

14 Elephant Parade
Sacramento Archives
1985/24/5870

15 Agricultural Park
Sacramento Archives
1985/24/5393

16 Electric Streetcar
Sacramento Archives
1985/24/3017

17 Patrol Wagon
Sacramento Archives
2001/07/127

18 Horse Auction
Sacramento Archives
1985/24/1949

19 Huntington Memorial
Sacramento Archives
1984/62/226

20 Oak Park
Sacramento Archives
1985/24/5889

21 Breuner's Furniture
Sacramento Archives
2001/59/656

22 Wells Fargo
Sacramento Archives
1989/41/4914

23 Noorhies & Co.
Sacramento Archives
1985/24/5912

24 J Street
Sacramento Archives
1985/24/1970

25 Sacramento River Jail
Sacramento Archives
1984/62/149

26 Mechanic's Store
Sacramento Archives
1995/44/14

27 Old Wayside Bar
Sacramento Archives
1982/62/179

28 Chinese Parade
Sacramento Archives
1984/62/228

31 Sacramento County Courthouse
Sacramento Archives
2001/16/34

32 J Street Shops
Sacramento Archives
1985/24/1982

33 Northern Electric Depot
Sacramento Archives
1985/1986

131 OWL DRUG CO.
Sacramento Archives
1970/01/19

132 FIREHOUSE #4
Sacramento Archives
1985/24/461

133 PONY EXPRESS
Sacramento Archives
1986/75/42

134 STREETCAR
Sacramento Archives
1989/41/4896

135 SUTTER'S FORT
Sacramento Archives
1973/03/1145

136 CALIFORNIA CAPITOL
Sacramento Archives
1989/41/4562

137 K STREET
Sacramento Archives
1985/24/6093

138 THE "AKRON"
Sacramento Archives
1989/41/2559

139 10TH STREET
Sacramento Archives
1985/24/5168

140 MONTGOMERY WARD
Sacramento Archives
1985/24/6092

142 RED HEART PASTRY
Sacramento Archives
1973/03/48

144 "SPIRIT OF ST. LOUIS"
Sacramento Archives
1983/001/sbpm00169

145 POLICE OFFICERS
Sacramento Archives
2004/x-04/10

146 4TH STREET
Sacramento Archives
1985/24/1868

147 ALHAMBRA THEATRE
Sacramento Archives
2008/52/03

148 MOVIEGOERS
Sacramento Archives
1996/44/842

149 9TH STREET
Sacramento Archives
1985/24/1755

150 RAILROAD TRACKS
Sacramento Archives
1989/41/1014

151 FIRE AT EL RAY THEATRE
Sacramento Archives
1985/24/3220

152 FIREFIGHTERS AT EL RAY
Sacramento Archives
1985/24/3216

153 TRACK REMOVAL
Sacramento Archives
1985/24/4889

154 DEMOLISHED TRACKS
Sacramento Archives
1985/24/4894

155 ADMISSION DAY
Sacramento Archives
1985/24/1995

156 MERCY HOSPITAL
Sacramento Archives
2001/57/289

157 3RD STREET
Sacramento Archives
1985/24/1533

158 9TH STREET
Sacramento Archives
1985/24/3450

159 SACRAMENTO DOWNTOWN
Sacramento Archives
1985/24/4458

160 BRYTE BUILDING FIRE
Sacramento Archives
1985/24/3206

161 EDMOND'S FIELD FIRE
Sacramento Archives
2003/12/106

162 4TH STREET
Sacramento Archives
1985/24/1872

163 SUNRISE LAUNDRY
Sacramento Archives
85/24/1869

164 9TH STREET
Sacramento Archives
1985/24/1754

165 PRESIDENT HARRY TRUMAN
Sacramento Archives
2003/12/88

166 11TH STREET
Sacramento Archives
1973/03/1330

167 STATE CAPITOL
Sacramento Archives
1973/03/1171

168 AGRICULTURAL BLDG.
Sacramento Archives
1989/41/911

169 MUNICIPAL AIRPORT
Sacramento Archives
1998/722/05

170 SOUTHERN PACIFIC DEPOT
Sacramento Archives
1989/41/562

171 ADLAI STEVENSON
Sacramento Archives
1989/41/176

172 VETERANS MEMORIAL
Sacramento Archives
1989/41/4368

173 J STREET PARADE
Sacramento Archives
1989/41/2784

174 CAPITOL PARK
Sacramento Archives
1985/24/4717

175 2ND AND K STREETS
Sacramento Archives
1985/24/6344

176 GOVERNOR'S MANSION
Sacramento Archives
1973/03/1130

177 WEINSTOCK'S DEPARTMENT STORE
Sacramento Archives
1973/03/1130

178 SCOTTISH RITE TEMPLE
Sacramento Archives
1989/41/2657

179 SACRAMENTO FIREMEN
Sacramento Archives
1983/01/9788

180 FOX SENATOR THEATRE
Sacramento Archives
1989/41/3383